HOW TO PAINT
ACRYLICS

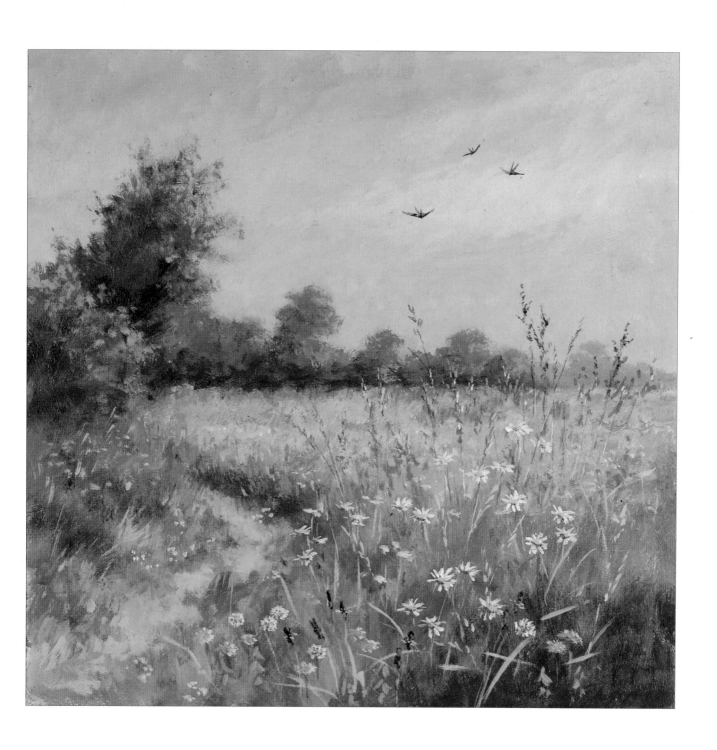

Dedication

To Anastasia, William, Vienna and Boris. Hoping you get as much pleasure from painting as I do.

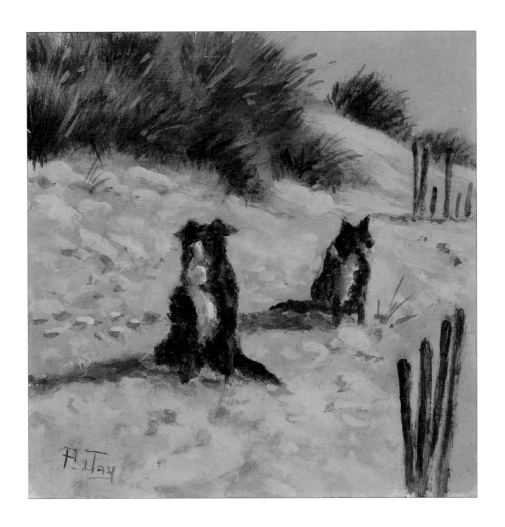

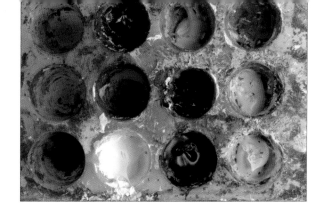

HOW TO PAINT
ACRYLICS

PETER JAY

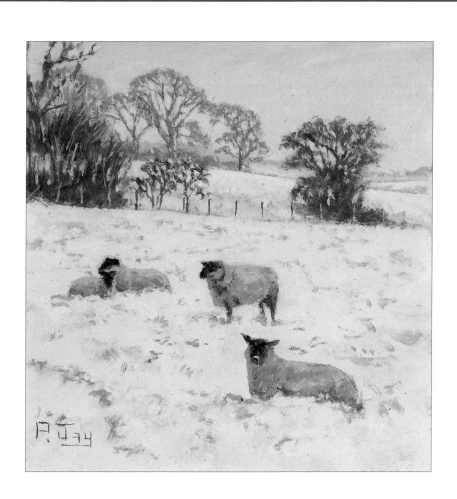

SEARCH PRESS

First published in Great Britain 2008

Search Press Limited
Wellwood, North Farm Road,
Tunbridge Wells, Kent TN2 3DR

Text copyright © Peter Jay 2008

Photographs by Debbie Patterson at Search Press Studios

Photographs and design copyright © Search Press Ltd, 2008

ISBN: 978-1-84448-295-5

The Publishers and author can accept no responsibility for any
consequences arising from the information, advice or instructions given
in this publication.

Suppliers
If you have difficulty in obtaining any of the materials and equipment
mentioned in the book, please visit www.winsornewton.com for details
of your nearest Premier Art Centre.

Alternatively, please phone Winsor & Newton Customer Service on
020 8424 3253.

Publishers' note

All the step-by-step photographs in this book feature the author,
Peter Jay, demonstrating acrylic painting techniques. No models
have been used.

Printed in Malaysia

Acknowledgement

*With many thanks to Annie for her patience and
support in this venture.*

Cover
Poppies on the Downs
20.3 x 20.3cm (8 x 8in)

Page 1
Track Through Wild Flowers
20.3 x 20.3cm (8 x 8in)

Page 2
Dune Dogs
12.7 x 12.7cm (5 x 5in)

Page 3
Sheep in Winter
15.3 x 15.3cm (6 x 6in)

Contents

Introduction

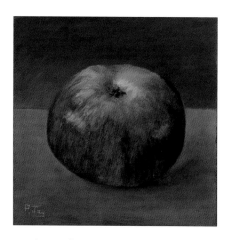

Red Apple
15.3 x 15.3cm (6 x 6in)
It was partly through painting apple studies like this one that I learned about painting from close observation.

I started painting with acrylics over thirty years ago, having previously used oils. I was working in the manner of the French Impressionists, using small dabs of colour rather than large brush strokes. I found the quick-drying properties of acrylics meant that I could build the painting layer upon layer without the colours mixing or becoming muddied.

Later, when I was painting much more detailed landscapes, using acrylics meant that I could add wild flowers to the foreground straight away, whereas with oils I would have had to let the painting dry for some days before adding the detailed flower work.

I never studied full time at an art school, but I did go for many years to evening classes for life drawing and portrait painting. One of the most important things I learned there was observation: how to look at things and draw them as they really are and not as you think they should be. I was told that there were as many problems with painting an apple as with a portrait if you studied it. I took this to heart, and some of the first paintings I sold were my apple studies.

When I moved to the country, it was the wild flowers that caught my attention and I spent a year doing detailed studies of them, trying to paint at least one a day to really get to know them. There was always something to paint; even in winter there were berries, mosses, lichens and seed heads. I used acrylics for these studies but in a different way. I would do the drawing using a fine black ballpoint pen with waterproof ink. I then coloured in the drawing with acrylics as if they were watercolours.

This shows something of the versatility of acrylics: you can use them like oil paints or like watercolours. I use both techniques in the same painting by using the oil colour method for most of the landscape and adding the flower details with a fine watercolour brush and dilute acrylic paint.

You could say that I am self-taught when it comes to landscape painting, as before moving to the country, I had been studying mainly portrait and life painting. However, I was inspired to paint landscapes by the works of Constable, Gainsborough and the Pre-Raphaelites, particularly Millais. I started learning about wild flowers and how to paint them from the Reverend William Keble Martin's wonderful *Concise British Flora in Colour*. So in reality I was not self-taught; I had some very good teachers!

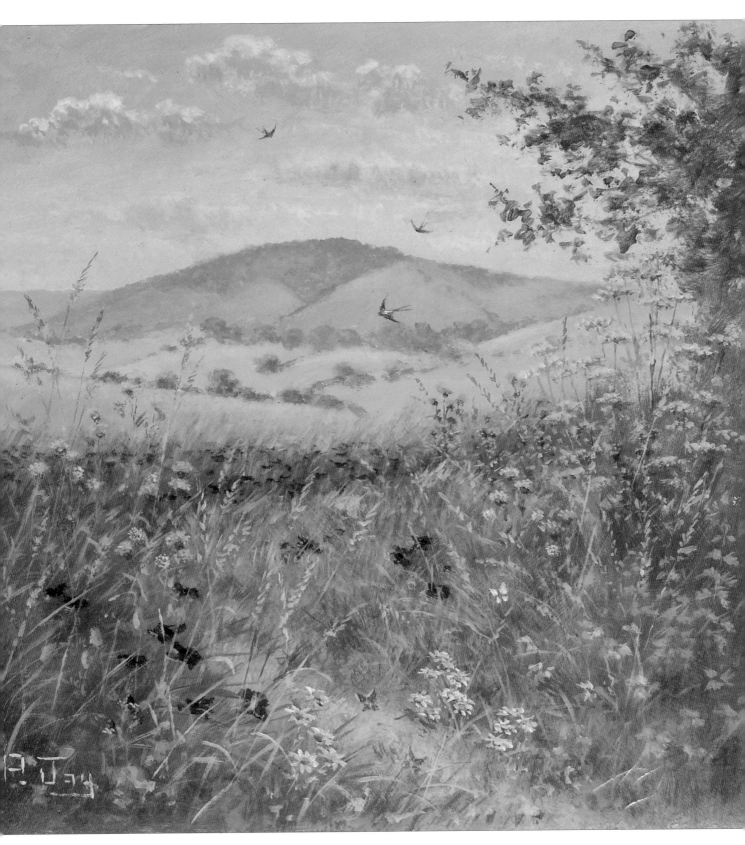

The South Downs in Summer
20.3 x 20.3cm (8 x 8in)

Materials

Acrylic paints

I use Winsor & Newton, Artists' Acrylic colours of which there is a vast range. However, I find that using a limited palette gives a unity to the painting. My colours are titanium white, ultramarine blue, lemon yellow, cadmium yellow deep, cadmium yellow medium, yellow ochre, burnt umber, cadmium red medium, alizarin crimson and Payne's gray.

I also use a wash of Venetian red on my boards before I start a painting. I find mixing the yellows with the ultramarine gives a wonderful range of greens.

To keep the paints moist, I squeeze small quantities into an ice cube tray which I keep covered with a damp cloth when I am not working. They will keep for several days like this. To prevent the cloth drying out, I cover it with my palette, which is a piece of glass covered with primed paper. I do not try to clean the palette but change the paper about twice a year.

Please remember to replace caps on the tubes of paint to prevent them drying out.

My ice cube tray covered with a damp cloth to keep the paints moist, and with my palette on top.

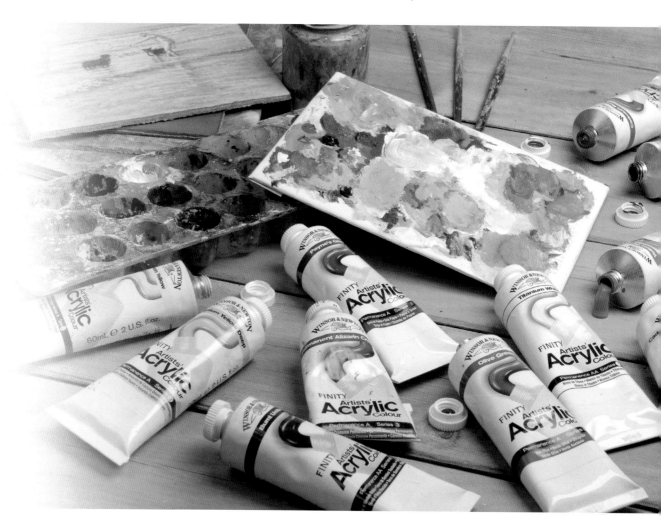

Brushes

The brushes I use are mainly Artists' Hog by Winsor & Newton. I use the short flat ones in the early stages of a painting for covering large areas and I have three sizes – no. 2, no. 6 and no. 8. The round brushes are for more detailed work and I use no. 2 and no. 4. For the final stages, when I am painting wild flowers and grasses, I use a fine, round, no. 1 size watercolour brush. This is a sable/synthetic mix in the Sceptre Gold II range, also by Winsor & Newton.

Remember to keep the hog brushes in water when not actually using them, as they can dry very quickly. However, I do not leave the watercolour brush standing in water, as this would spoil the shape, so I clean it well every time I use it.

A round brush.

A flat brush.

Left to right: short flat hog no. 8, no. 6 and no. 2; round hog no. 4 and no. 2 and watercolour no. 1.

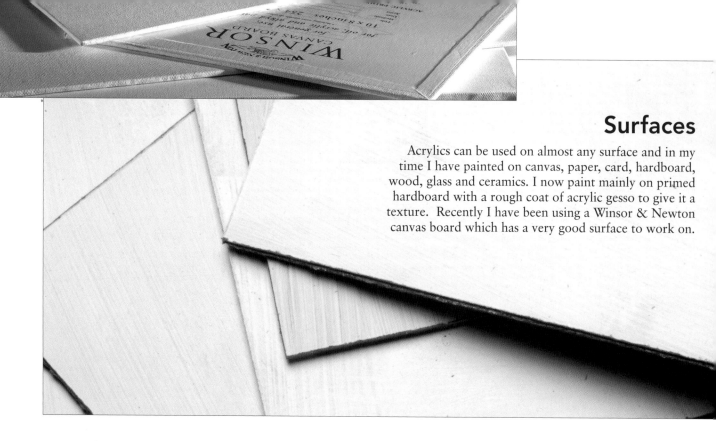

Surfaces

Acrylics can be used on almost any surface and in my time I have painted on canvas, paper, card, hardboard, wood, glass and ceramics. I now paint mainly on primed hardboard with a rough coat of acrylic gesso to give it a texture. Recently I have been using a Winsor & Newton canvas board which has a very good surface to work on.

Outdoor sketching kit

Before I paint, I sketch. I try to go out every day with my sketching things.
I sketch with a fine black pen which, being waterproof, does not run when I apply watercolours. I use watercolours for sketches rather than acrylics as in the open air, the quick-drying properties of acrylics are enhanced and can be a problem. Along with my sketchpad and watercolour paint box, I take a brush, a camera and film, binoculars, a compass in case I get lost and secateurs for removing brambles from footpaths. I also take small water containers
for watercolour painting.

My outdoor sketching kit bag,
camera and film, compass, binoculars,
watercolour paint box, paint brush, fine,
waterproof black pen, water containers
and secateurs.

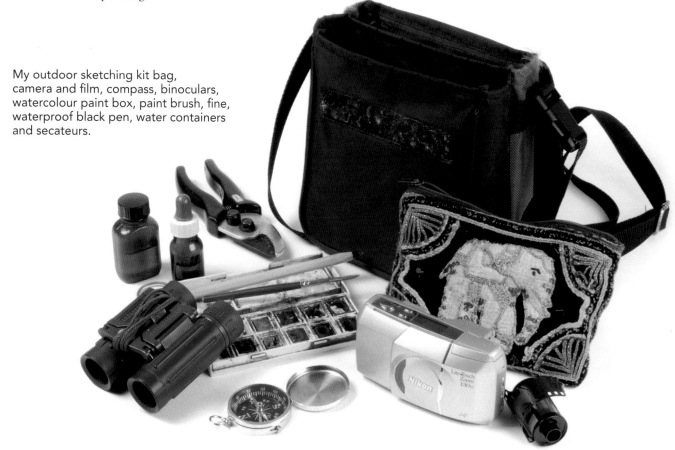

10

Other materials

When preparing hardboard for a painting, I lightly sand the smooth side of the board with fine sandpaper. This gives a better surface for a rough coat of acrylic gesso primer. This is applied next with an ordinary household painting brush, to create a textured surface on which to paint.

I use charcoal for the initial drawing which is then lightly dusted off with a rag to remove any excess.

When the finished painting is dry, I varnish it with acrylic gloss varnish, which I apply with a rag. The varnish provides a protective layer for the painting, with a gloss sheen.

My home-made desk easel is designed to take various sizes of board, which are propped up at an angle while I work.

Glass water jars are used to clean brushes, and I have various sizes for the different brush sizes.

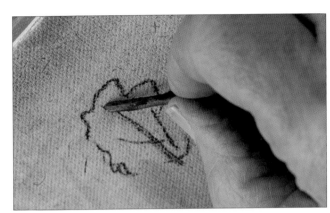

After priming the board and painting on a wash of Venetian red, I draw the scene in charcoal.

My home-made desk easel, glass water jars, charcoal, sandpaper, gloss varnish, acrylic gesso primer and a rag.

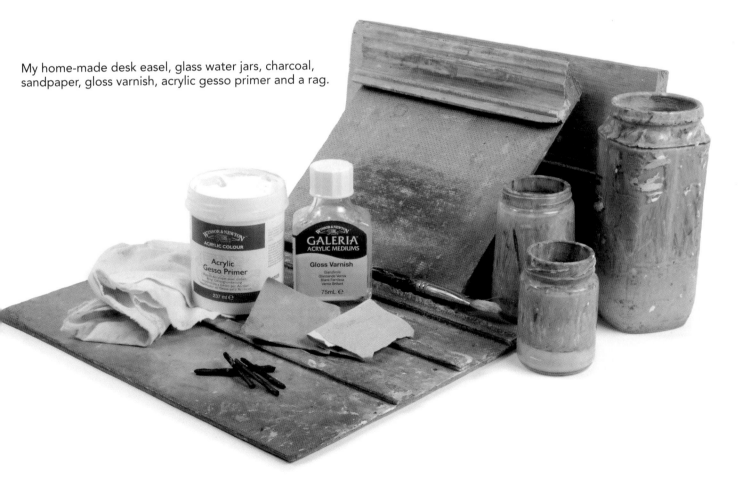

Techniques

On the following pages I demonstrate my techniques for creating a painting. Starting with the preparation of the board, I move on to the charcoal drawing of a scene from my sketchbook. Then comes the painting. You will see how I build up the picture from the initial rough blocking in to the final addition of wild flowers and grasses.

Primed board 20.3 x 20.3cm (8 x 8in) and acrylic gesso

Charcoal

Colours: Venetian red, white, ultramarine blue, yellow ochre, cadmium yellow deep, cadmium yellow medium, lemon yellow, Payne's gray, burnt umber and alizarin crimson

Brushes: short flat no. 8, no. 1 round, short flat no. 6, no. 4 round and no. 2 round

Rag

Preparing the surface

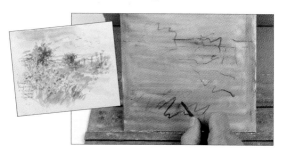

1 I prime hardboard with acrylic primer and then cut it to size, but you might want to use a pre-primed canvas board. Paint on a rough coat of acrylic gesso to create texture.

2 Apply a coat of watered-down Venetian red paint over the whole board with a short flat no. 8 brush.

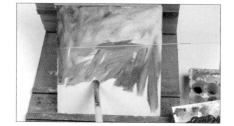

Drawing the scene

3 Referring to your sketch, use charcoal to do a rough drawing of the scene.

4 Dust off any excess charcoal using a rag. Take a fine no. 1 brush and use ultramarine blue to 'draw' over the charcoal lines.

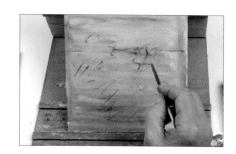

Beginning to paint

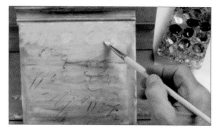

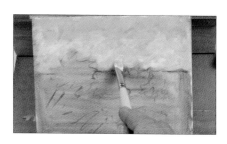

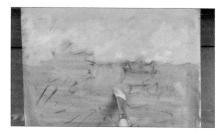

5 Fill an ice cube tray with all the colours you are going to use. On a palette, mix white, ultramarine and a tiny bit of lemon yellow and use a short flat no. 6 brush to paint the top of the sky with rough strokes.

6 Add a little more white to paint the lower part of the sky.

7 Mix a little ultramarine and yellow ochre with white paint and block in the far distance.

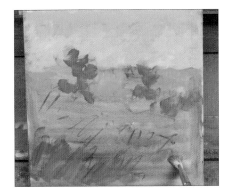

8 Block in the shaded parts of the greenery using a mix of ultramarine, yellow ochre and a little cadmium yellow deep.

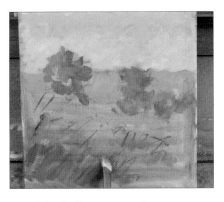

9 Add a little more cadmium yellow deep to the same mix to make it brighter and block in the sunlit sides of the bushes and the grasses beside the track.

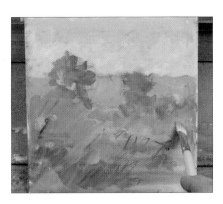

10 Add yellow ochre to create a more autumnal green and paint the larger part of the grasses.

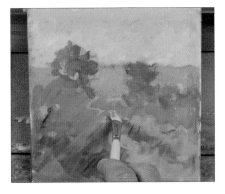

11 Use the same mix with a little white added to start picking out the track.

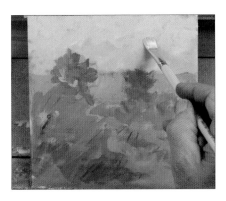

12 The sky is now dry enough to begin working into it again. Pick up white mixed with ultramarine blue and a little lemon yellow and work over the previous colour.

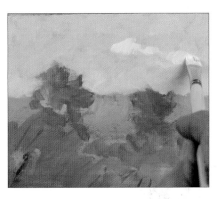

13 Mix in a little more white and starting on the horizon line, work up to join the earlier blue. Use pure white to touch in a few clouds.

Building up layers

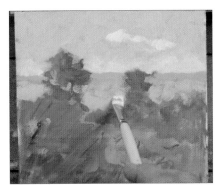

14 Mix ultramarine blue and yellow ochre and go over the far distance again. Add a little more white lower down, near the grasses.

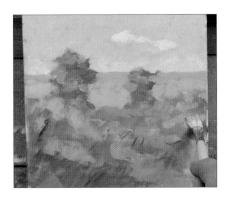

15 Add more green mixed from cadmium yellow medium and ultramarine blue, and cover most of the red undercoat.

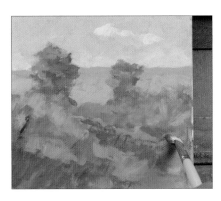

16 Add a little more ultramarine to the mix and go back over the shadowed areas of the bushes.

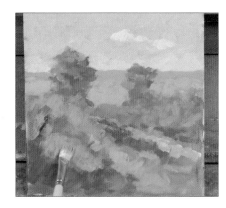

17 Add a little more white to the mix and pick out the track.

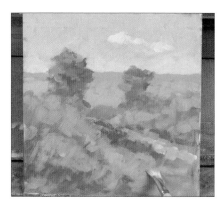

18 Paint yellow ochre mixed with a little white into the autumnal grasses with quick dabs of the brush.

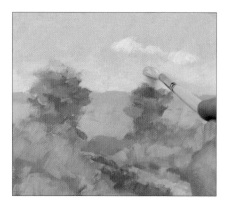

19 Take the no. 4 round brush and go over the sky again with the ultramarine, white and lemon yellow mix. Work into the previous coats fairly roughly for an impressionistic effect. Add more white lower down.

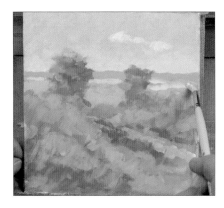

20 Continuing with the no. 4 round brush, use ultramarine and yellow ochre to work into the background again. Pay careful attention to the sketch to suggest fields among the distant hills.

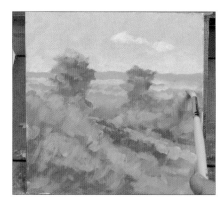

21 Darken the mix with a little ultramarine and cadmium yellow deep and pick out trees and hedges in the background.

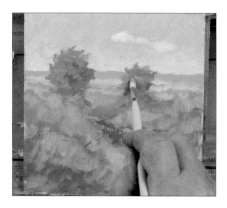

22 Work into the sunlit side of the bushes to give them shape using the same mix.

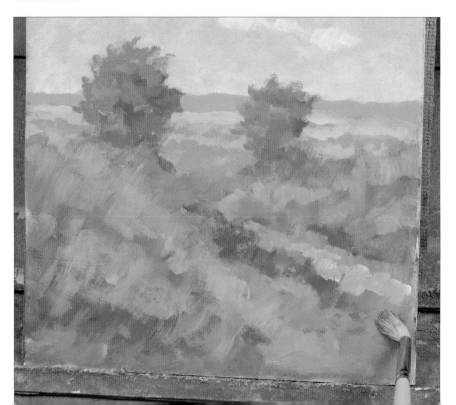

23 With the same mix, work into the grassy areas where the background colour shows through. Using the tree colour in the grass in this way creates unity in the painting.

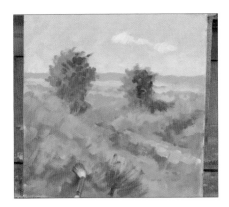

24 Still using the no. 4 round brush, mix Payne's gray with cadmium yellow deep to make a dark green and paint the shaded side of the bushes. Add shade to the grasses as well.

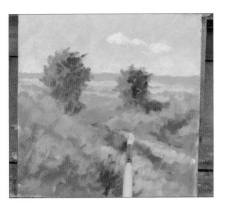

25 Clean the brush and pick up yellow ochre with white to pick out the path more clearly.

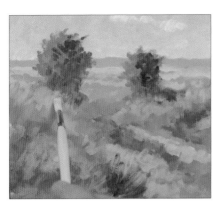

26 Add more yellow ochre to the mix and pick out the places where the light catches the grasses.

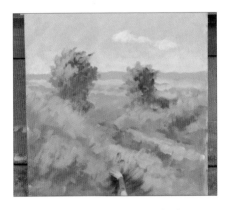

27 Add lemon yellow and white to the mix and use the tip of the brush to paint light details on the bushes and grasses.

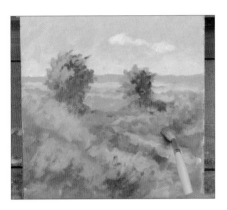

28 Add definition to the edges of the path using ultramarine mixed with yellow ochre, cadmium yellow deep and a little white.

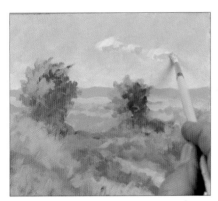

29 Change to the no. 2 round brush to paint further detail. Work on the clouds to give them form, adding shadows with a mix of white, ultramarine and a little burnt umber.

Painting detail

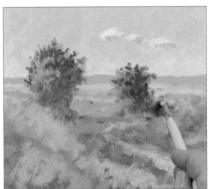

30 Using the same brush, add detail to the bushes with a mix of ultramarine and cadmium yellow deep. You can now draw in detail rather than blocking it in as you were before.

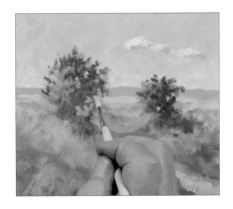

31 Using a mix of ultramarine and cadmium yellow medium, work on the shape of the bushes, refining their edges.

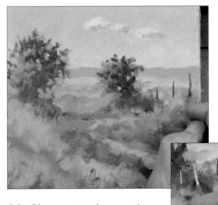

32 Change to the no. 1 brush and paint the fence posts with a mix of ultramarine and yellow ochre. Add a little white and paint the fence posts against the dark bush.

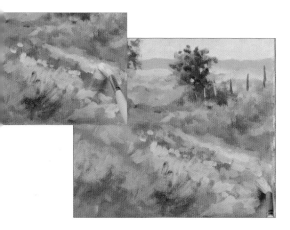
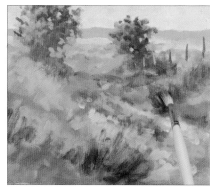
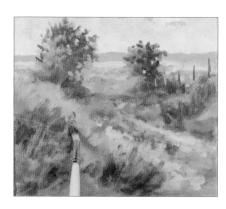

33 Change to the no. 4 round brush and paint into the path with yellow ochre and white. Add a little cadmium yellow deep to the mix and continue painting the path.

34 Mix Payne's gray, cadmium yellow deep and ultramarine and paint the darker parts of the grasses.

35 Now mix burnt umber with cadmium yellow deep to make a warm shade and paint this into the grasses.

Adding fine detail

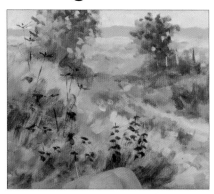
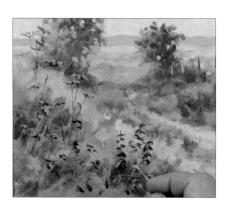
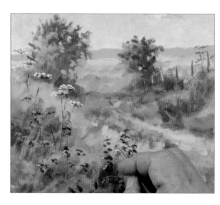

36 Change to the no. 1 brush again for the fine details of the plants. Use ultramarine and yellow ochre to paint hogweed on the left and brambles and nettles in the foreground.

37 Mix white, ultramarine and cadmium yellow deep to add form to the hogweed, brambles and nettles.

38 Build up the hogweed with white, and add a few highlights to the brambles and nettles.

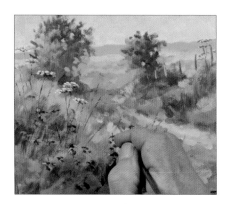
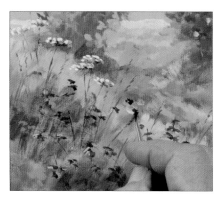
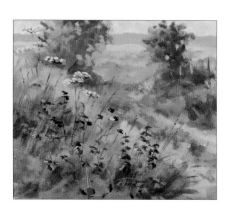

39 Still using the no. 1 brush, paint grasses with a mix of yellow ochre and ultramarine, diluted so that it flows easily.

40 Paint in the knapweed with alizarin crimson mixed with a touch of ultramarine.

41 Add stalks to the knapweed with a mix of ultramarine and yellow ochre.

42 Add a little white to the alizarin crimson and ultramarine mix and paint in lighter parts on the sunlit sides of the knapweed to give it a three-dimensional look.

The finished demonstration. For the purposes of this section I have stopped painting at this point. Usually I would carry on painting for several more hours, adding more detail especially to the plants.

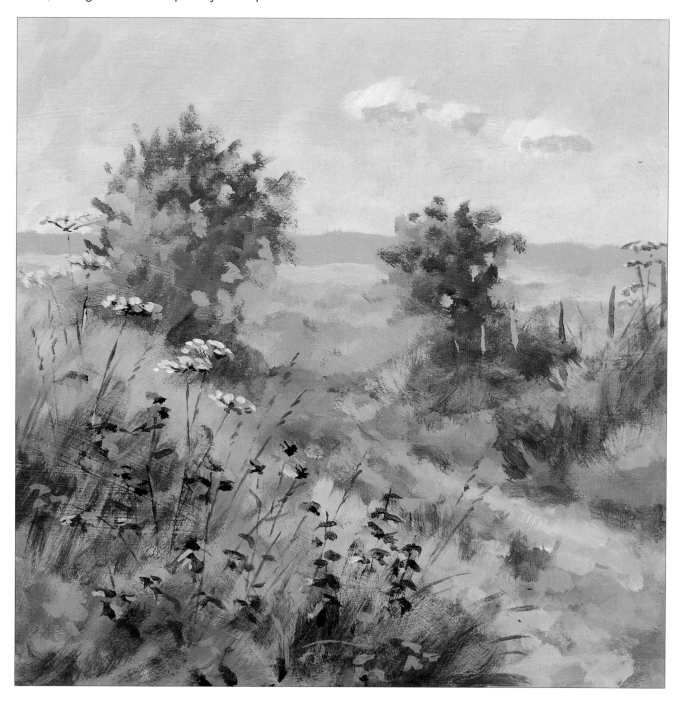

Sketching

I try to go out sketching most days and it is often a display of wild flowers that is the impetus for a sketch. This means I am usually sitting on the ground, so that these flowers are in the foreground of my composition.

I use a fine ballpoint pen which, being waterproof, does not run when I add watercolours. I make notes of the flowers and grasses and the occasional nature note such as weather conditions and when I see the first swallow and hear the first cuckoo. A coloured sketch with notes will usually take about twenty minutes.

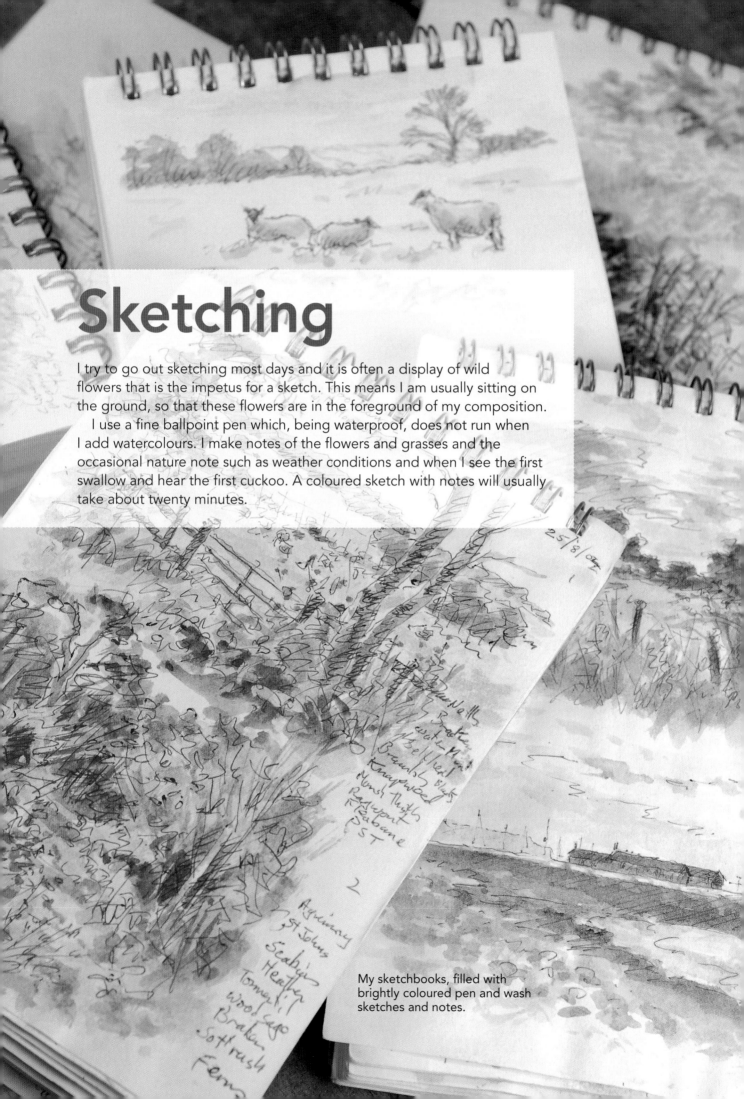

My sketchbooks, filled with brightly coloured pen and wash sketches and notes.

Using photographs

Although I prefer painting from my sketches, photographs are certainly useful for reference. I take pictures of wild flowers in their natural setting, which helps with the final painting, as in sketches I portray them in a sort of shorthand. Also photographs of farm animals and people on the beach are useful for adding interest to countryside or beach compositions.

The photograph above of poppies on the South Downs not only shows the flowers but also the buds and seed heads and a variety of grasses.

The foxgloves pictured above show good details of both flowers and leaves. There are also some interesting details of chestnut leaves.

This amazing field of ox-eye daises also shows sorrel, buttercups, yellow rattle and grasses.

Composition

When I start a sketch it is not composition that I first think about. I see a view that I feel I want to paint and get on with it. It is only when I'm doing the drawing that I realise that what attracted me in the first place was the composition.

There may be a track creating an interesting diagonal, balanced by opposing diagonals of a hedgerow or distant hills. This produces a satisfying 'Z' shaped composition.

The track may lead the eye to a focal point such as a tree or stile. Very often this is about a third of the way across the painting. For some reason this principle of thirds makes for satisfying compositions. Looking at my paintings, I often see the rule of thirds has been used, with the horizon about a third of the way down and a vertical focal point about a third of the way across. This was not consciously thought about at the time of doing the sketch; it just felt right.

It is interesting to look at a painting in progress upside down or in a mirror, as this often shows what is needed to improve a composition. A large tree may need just a small, bright flower to balance it or perhaps some swallows to continue to a 'Z' composition. In the end it is a question of 'does it feel right?'

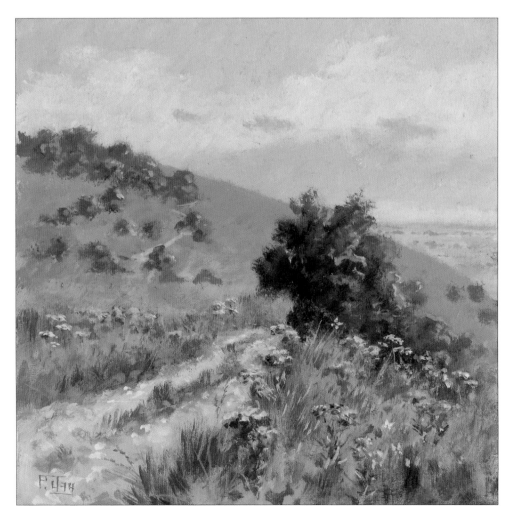

Chalk Track with Ragwort
20.3 x 20.3cm (8 x 8in)

In this painting, the main feature in the composition is the track itself. It leads the eye into the painting until it disappears behind the bush on the right, before reappearing on the next hill. The two diagonals of the track and the far hill are stabilized by the horizon and the large bush which acts as a sort of anchor.

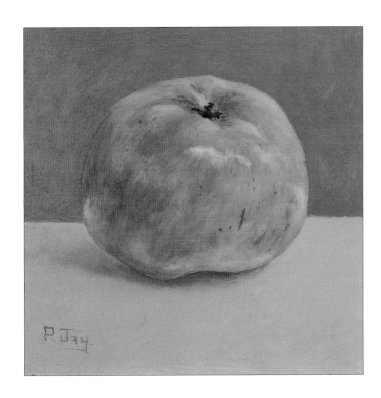

This painting seems to break the rules by being right in the centre of the picture. However, the eye is caught by the off-centre horizontal line cutting the curve of the apple. The similar proportions of the three colours also give a feeling of balance.

Apple
12.7 x 12.7cm (5 x 5in)

This painting is again a composition of diagonals. These are broken by the hedgerow post and the large tree on the left, both of which lead the eye to the sheep in the centre.

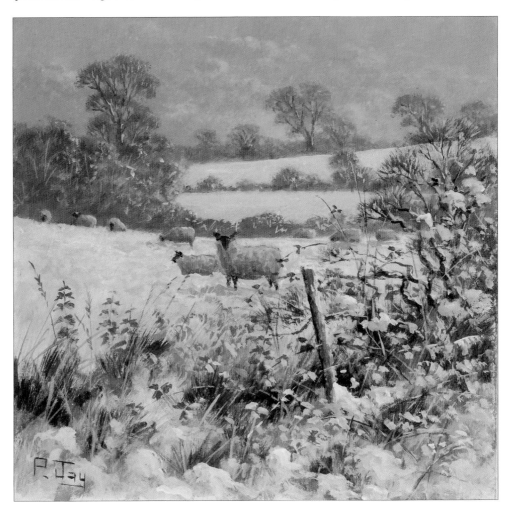

Winter Hedgerows
20.3 x 20.3cm (8 x 8in)

Perspective

Perspective is the way of achieving depth on a two-dimensional surface. The basis of linear perspective is that parallel lines appear to converge as they get further away and objects get smaller. In a landscape painting, a track may appear to get narrower as it recedes and trees alongside this track get smaller. Aerial perspective continues this illusion by bringing atmosphere into the equation. The further away an objective is, the less detailed it becomes, the less colour contrast there is and the bluer it appears. Therefore a distant hill with trees and fields would be painted in light tones of blues and blue/greens in contrast to the stronger, brighter colours of the foreground.

Linear perspective

In the painting below, as well as the aerial perspective of the distant hills, there is also the track itself leading the eye deep into the painting. This feeling of the path going away is created by the gradual narrowing of its width. The fence posts on the right reinforce this impression by getting smaller and closer together.

A Downland Track
25.4 x 25.4cm (10 x 10in)

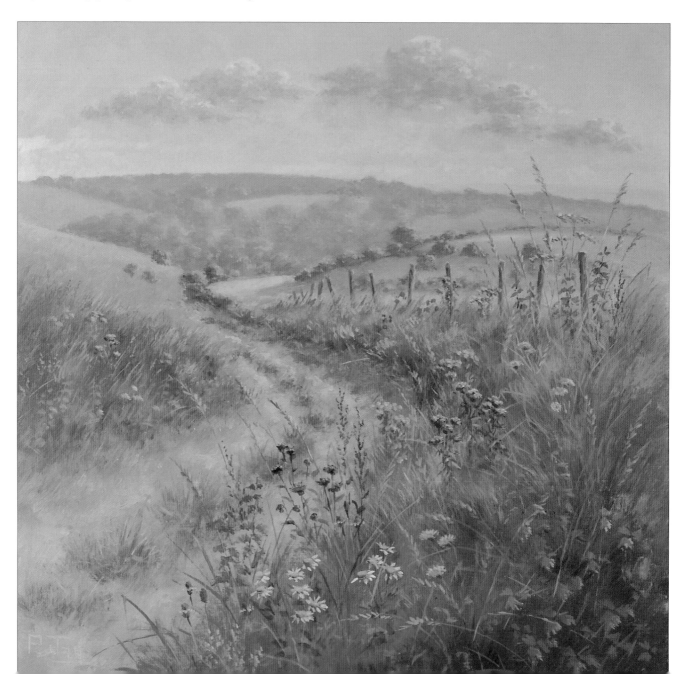

Aerial perspective

In the painting below, the gradual lightening of the background trees creates a feeling of distance. The hazy blueness of the trees on the far right enhances this effect.

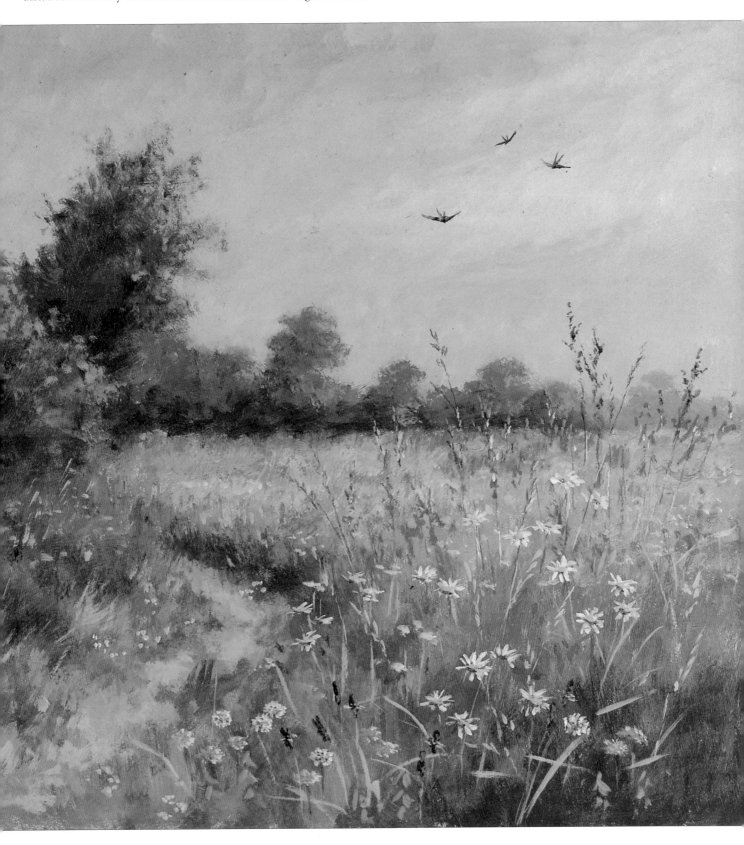

Track Through Wild Flowers
20.3 x 20.3cm (8 x 8in)

Demonstrations

The first demonstration painting, On the Rocks, is of two young shrimpers checking out the rock pools on Bexhill Beach. I was attracted by their cautious negotiations of the slippery rocks. They had been trying their luck in the shallow pool in the foreground and were investigating the possibilities of the deeper pools when I did my sketch.

The next demonstration, Winter Sheep, was sketched on a cold morning walk. The sheep all stopped their browsing when they saw my dog and decided to pose for me. It is unusual for sheep to stand still for long so I sketched them quickly first and then thought about the composition with the background trees and hills.

The third demonstration, Track Through Hills, is of the South Downs Way, which stretches for about ninety miles through southern England with numerous vantage points for painting. I walked the whole route some years ago and return time and again to my favourite spots. This is one of them, where the chalk track curves down to Alfriston in the Cuckmere Valley. It was the bush on the left with the dog roses that persuaded me to sit down and sketch this view.

The landowner of the field portrayed in Poppies in a Daisy Field is a great wild flower fan. He includes wild flower seeds when sowing his crops so his cornfields are bright with corn marigolds and cornflowers, etc. This field was mainly mayweed with the occasional splash of poppies and thistles. The broad grass margins to all his fields are so he can go everywhere by horseback and are very useful for one particular artist!

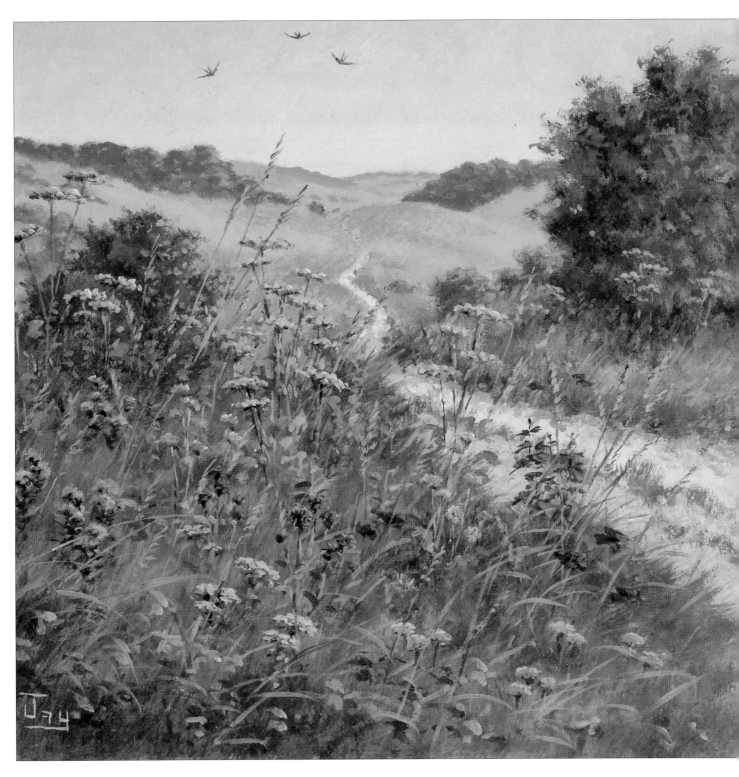

Summer on the Downs
20.3 x 20.3cm (8 x 8in)

On the Rocks

My original plan was to sketch the two boys shrimping in the foreground pool with their reflections in the water. By the time I had my sketchbook out they were on the rocks. I had lost the reflections but gained the silhouette effect against the sea. It is now a composition of contrasts – the light and dark shirts, the still pool and the choppy sea separated by the rocks. The structural elements of the composition are based on the principle of thirds. The high horizon balances the foreground rocks and the strong vertical of the boy in blue.

You will need

Primed board 15.3 x 15.3cm (6 x 6in) and acrylic gesso

Charcoal

Colours: Venetian red, ultramarine blue, white, lemon yellow, cadmium yellow deep, Payne's gray, cadmium yellow medium, yellow ochre, burnt umber

Brushes: no. 1 round, no. 4 round, no. 2 flat, no. 2 round

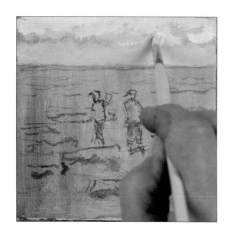

The pen and wash sketch.

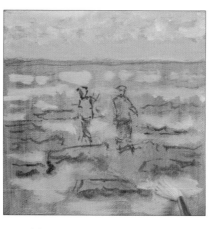

1 Prepare the surface and draw the scene in charcoal as shown on page 12. Then go over the drawing with the no. 1 brush and ultramarine blue paint.

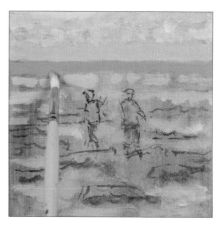

2 Mix a sky blue from ultramarine, white and a little lemon yellow and paint it on with a no. 4 round brush.

3 The sky should be darker towards the sea horizon this time, so add more white to paint the top and blend it down into the blue.

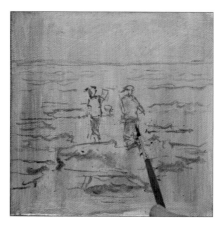

4 Add a tiny bit more lemon yellow to the mix and begin to paint areas of the sea.

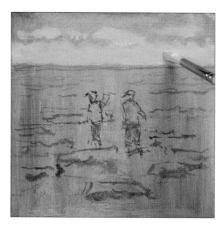

5 Add more ultramarine and cadmium yellow deep to the mix and paint the sea horizon.

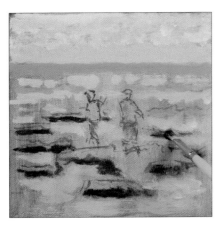

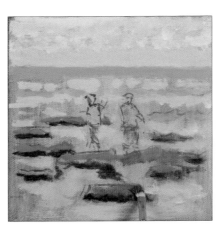

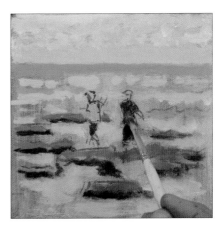

6 Take a no. 2 flat brush and mix Payne's gray and cadmium yellow medium to paint the shaded parts of the rocks.

7 Add yellow ochre and white to the mix and block in the top surfaces of the rocks.

8 Change to the no. 2 round brush and make a dark mix of ultramarine and cadmium yellow deep. Begin painting in the darker garments.

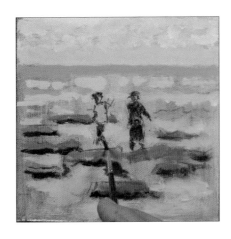

9 Change to the no. 1 brush and use the same colour mix to block in the hats and other details.

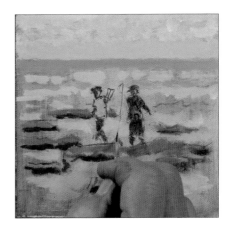

10 Use the same brush and colour to draw in the shrimping nets.

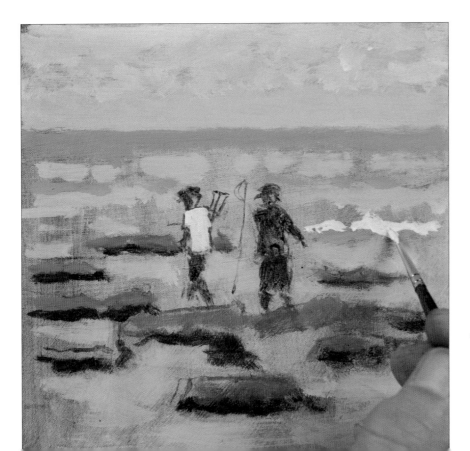

11 Still using the no. 1 brush, use white to paint the shirt of the boy on the left and the breaking wave.

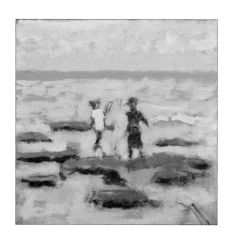

12 Mix a very pale sky colour from white, ultramarine and a little yellow lemon and use the no. 2 round brush to block in more of the sea.

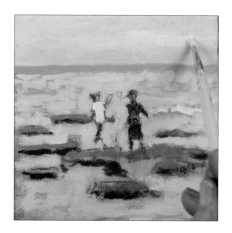

13 Add more white to the sky mix and work it down into the blue.

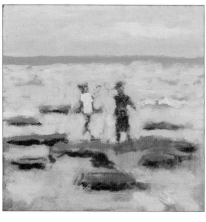

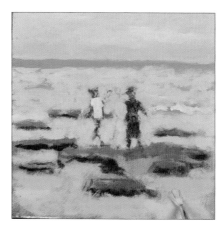

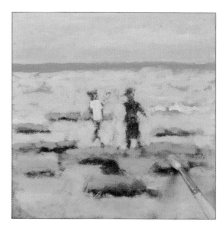

14 Work on the sea with the same mix lightened with a little white, making sure you leave the darker strip at the top.

15 Add a little yellow ochre to the mix to create a sandy colour where the shadows of the rocks will be.

16 Lighten the tops of the rocks with a mix of yellow ochre, white, a little cadmium yellow deep and a little ultramarine.

17 Change to the no. 1 brush. Use the lighter version of the sky colour (white, ultramarine and a little lemon yellow) to go round the figures, refining their shapes.

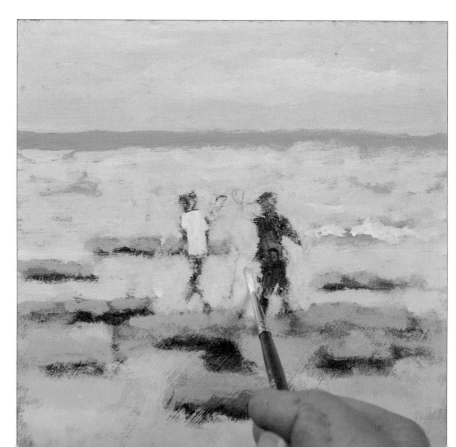

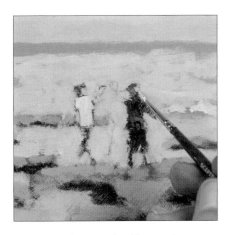

18 Use white and yellow ochre to paint where the light catches the right-hand side of the boys' heads, and parts of their arms, hands and legs.

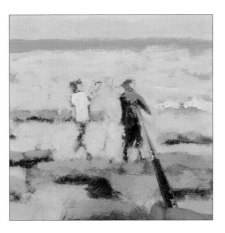

19 Work on the right-hand boy's shirt with a mix of ultramarine and yellow ochre, and add white to the mix where the light catches the shirt.

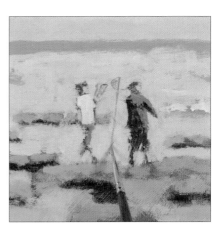

20 Use the darker mix to work on the nets.

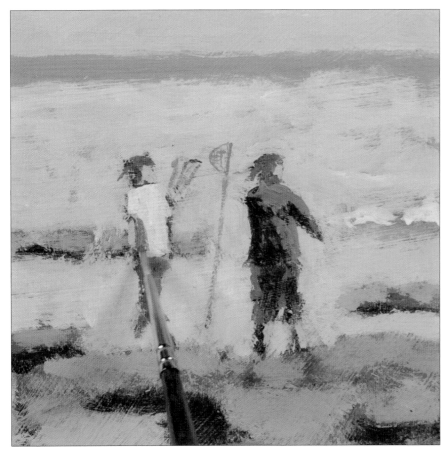

21 Use the same mix to tidy up the boys' trousers and paint a little shadow on the white shirt.

22 Paint yellow ochre on the backs of the boys' heads and on any areas of skin tone.

23 Add ultramarine to the yellow ochre to paint the right-hand boy's arm holding his net.

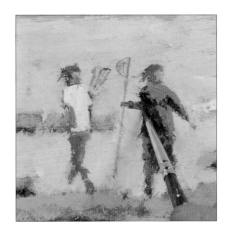

29

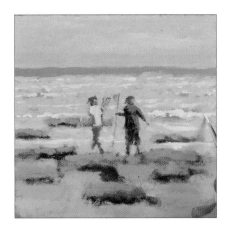

24 Paint the white crests of wavelets with the same no. 1 brush and white.

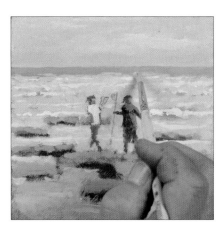

25 Change to the no. 2 round brush and use ultramarine, white and cadmium yellow deep to paint the darker sea horizon. Make sure you keep it straight.

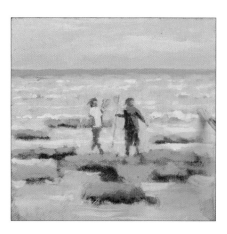

26 Add white to the mix and blend the dark horizon into the lighter sea colour. Continue adding the new mix to the sea.

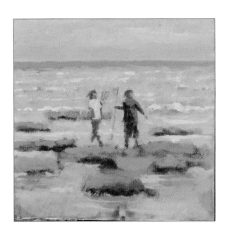

27 Mix yellow ochre and ultramarine to paint the rock reflections in the water.

28 Mix ultramarine and cadmium yellow deep with a touch of burnt umber and begin working in to the rocks.

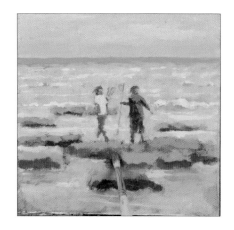

29 Mix cadmium yellow deep and ultramarine with a touch of white and paint the seaweed on the rocks.

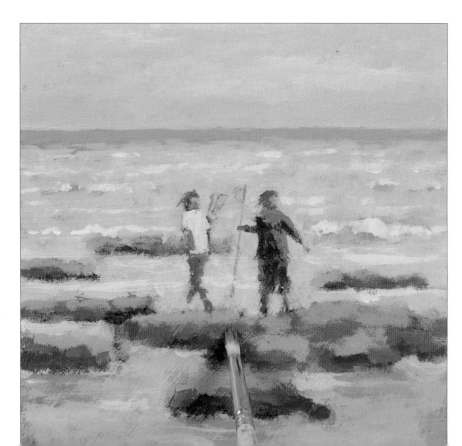

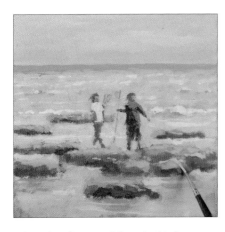

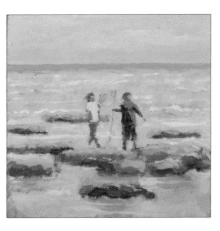

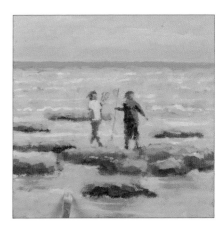

30 Take the no. 1 brush. Lighten the seaweed mix with white and highlight the rock surfaces.

31 Use the same brush and the sky mix of ultramarine, white and a little lemon yellow and tidy up round the rocks and the boys. Also add shadow to the breaking waves.

32 Add a little yellow ochre to the sky mix and use the no. 2 flat brush to paint some warmth and shine in the foreground.

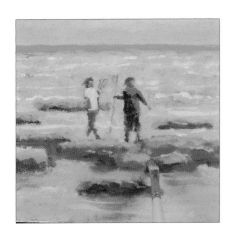

33 Mix ultramarine, yellow ochre and a touch of white and strengthen the outline of the rocks.

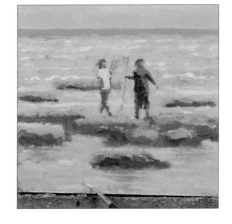

34 Change back to the no. 1 brush and use the sky mix of white, ultramarine and a little lemon yellow to paint little ripples in the reflections of the rocks.

35 Add ultramarine to the mix and go round the figures to improve the drawing.

36 Lighten the mix further to paint the boy on the right's shoulders where the light is strongest.

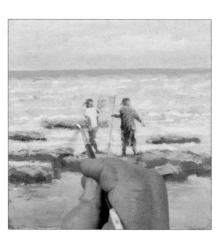

37 Mix yellow ochre and ultramarine and darken the rocks under the boys' feet to make it look as though they are standing there. Strengthen the other rocks.

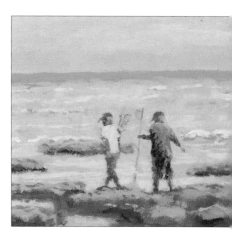

38 Mix ultramarine and lemon yellow and strengthen the shadow under the main breaking wave, then add more white to the wave to give it shape.

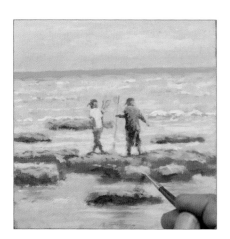

39 Use yellow ochre mixed with white to highlight the rocks.

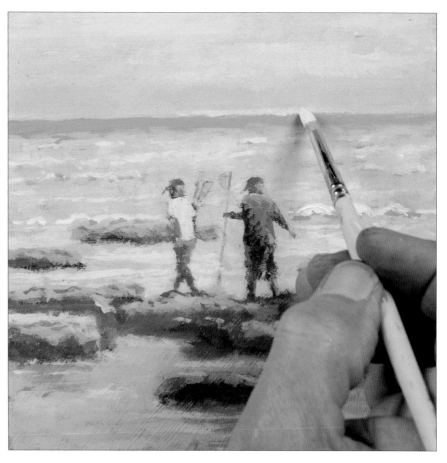

40 Change to the no. 2 round brush and lighten the sky at the top. Then add a tiny streak of light across the horizon.

41 Change to the no. 1 brush and use a mix of ultramarine and yellow ochre to redefine the right-hand boy's shoulder and add a bit of shape to his hat.

The finished painting.

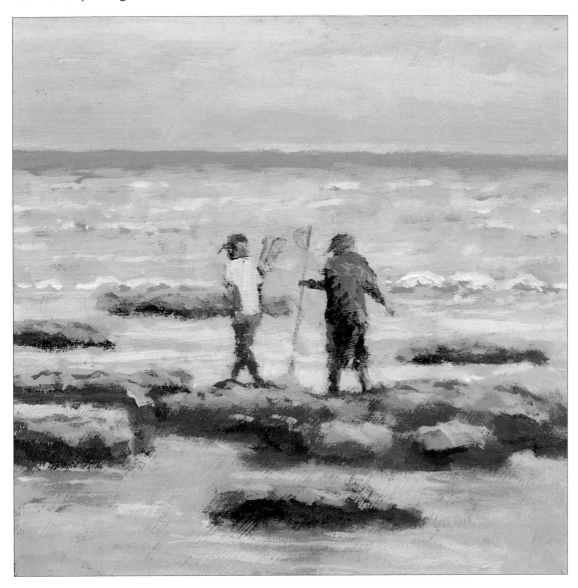

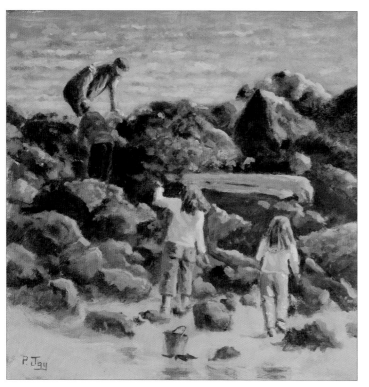

Rock Climbers
20.3 x 20.3cm (8 x 8in)

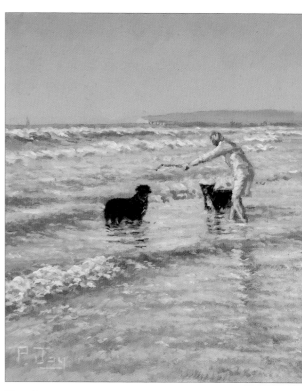

Fetch
15.3 x 15.3cm (6 x 6in)

Low Tide at Cliff End
20.3 x 20.3cm (8 x 8in)

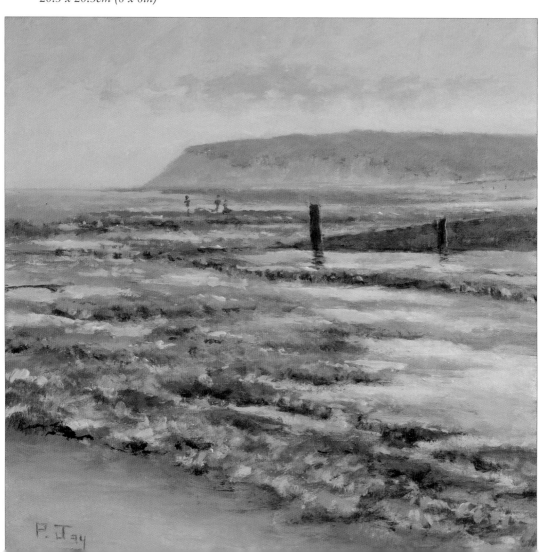

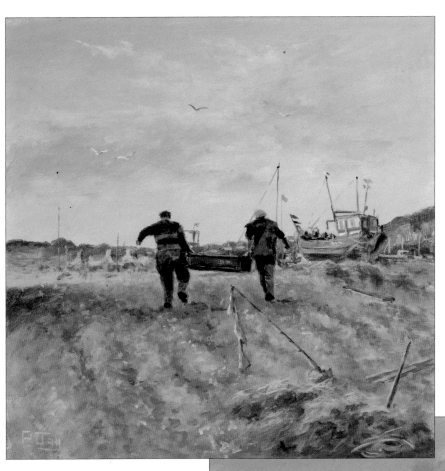

Bringing Home the Catch
20.3 x 20.3cm (8 x 8in)

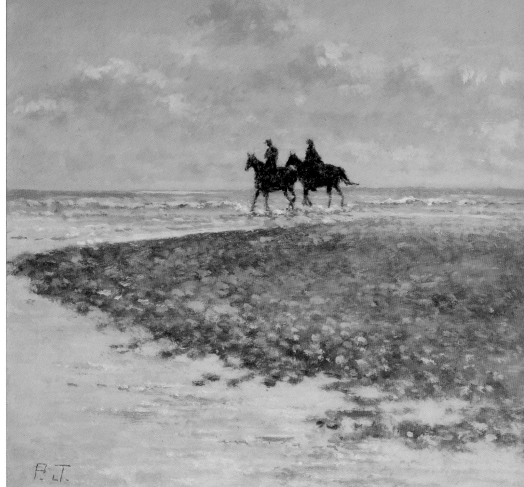

Surf Riders
20.3 x 20.3cm (8 x 8in)

Winter Sheep

The surprisingly dark shapes of the sheep against the snow inspired me to make the original sketch. The dark line of the background trees and distant hills creates a strong horizontal composition, broken by the tree on the left. Once again, the rule of thirds shows its hand. Perspective is realized by distant blues and of course the diminishing sheep sizes.

You will need

Primed board 15.3 x 15.3cm (6 x 6in) and acrylic gesso

Charcoal

Colours: Venetian red, ultramarine blue, white, lemon yellow, yellow ochre, Payne's gray

Brushes: no. 1 round, no. 4 round, no. 2 round

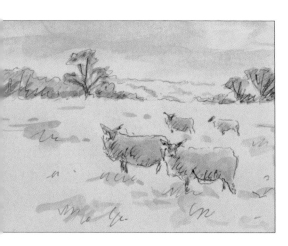

The sketch.

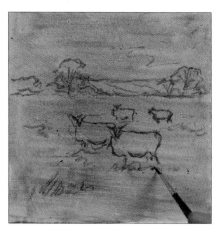

1 Prepare the board with acrylic gesso, then paint an undercoat of Venetian red. Draw the scene in charcoal, then go over the lines with the no. 1 brush and ultramarine blue.

2 Mix sky colour from white, ultramarine blue and a little lemon yellow and use the no. 4 round brush to begin blocking in the sky.

3 Add a little yellow ochre to the mix and paint the part of the sky near the horizon. Blend the colour upwards into the blue.

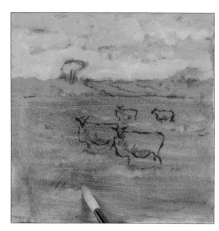

4 Mix ultramarine and yellow ochre and block in the distant trees and the shaded parts of the snowy field.

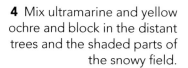

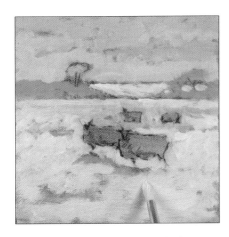

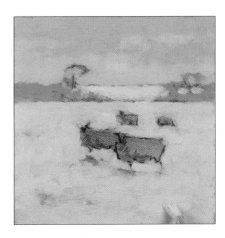

5 Use the same brush and white to block in the snow.

6 Go over the sky again, starting with white, ultramarine and a little lemon yellow at the top and then using white and yellow ochre lower down.

7 Go over the snow area again with more white paint.

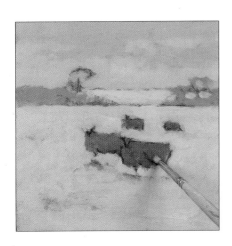

8 Change to the no. 2 round brush and paint the sheep with a mix of yellow ochre and a little ultramarine and white.

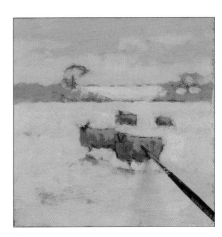

9 Add a little white to the mix and paint highlights on the sheep.

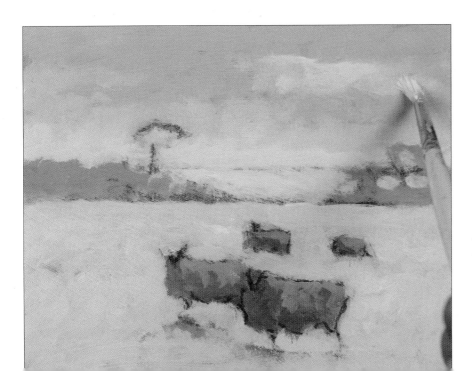

10 Add a little yellow ochre to white and paint the sky close to the horizon. Add some clouds higher up.

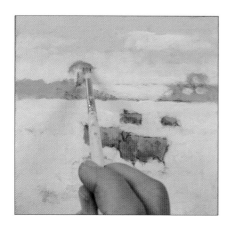

11 Paint the distant trees with ultramarine and yellow ochre.

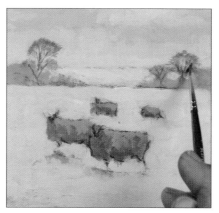

12 Change to the no. 1 brush and add water to the mix to dilute it so that it flows well. Add detail to the trees.

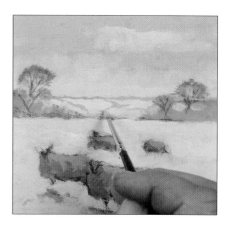

13 Add white to the diluted mix and paint trees and hedges in the far distant fields.

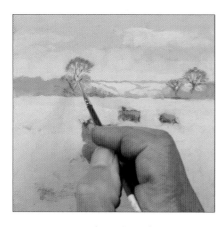

14 Return to the white and yellow ochre mix and paint areas of sky between the tree branches.

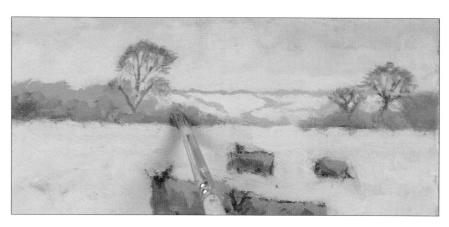

15 Change to the no. 2 round brush and mix yellow ochre, ultramarine and a little white to paint the trees and hedges in the distance.

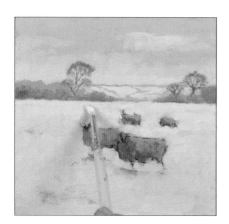

16 Mix white and a little ultramarine and re-establish the line where the snow meets the distant trees and hedges.

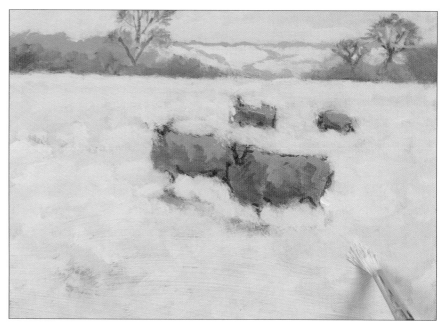

17 Paint thick dabs of white over the snow area.

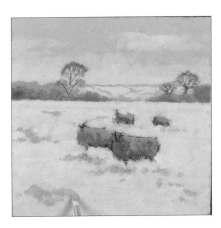

18 Mix ultramarine and yellow ochre to paint shadows in the snow and footprints near the sheep.

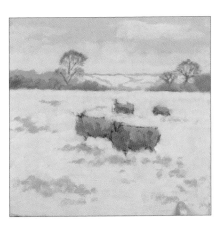

19 Add more yellow ochre to the mix and paint in patches of winter grass growing through the snow.

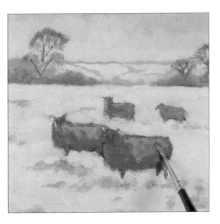

20 Mix yellow ochre and ultramarine and change to the no. 1 brush to sharpen up the edges of the sheep.

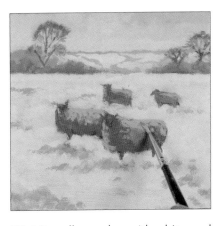

21 Mix yellow ochre with white and paint the wool on the sheep's backs.

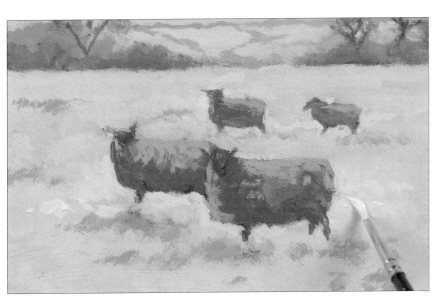

22 Use white to tidy up the edges of the sheep.

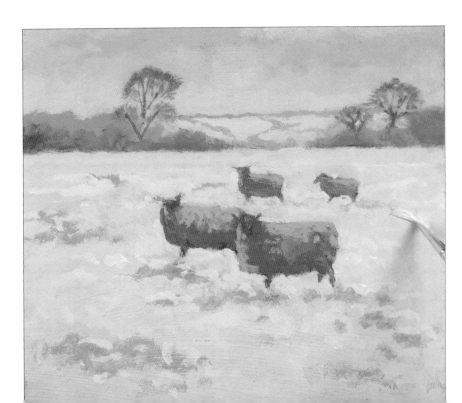

23 Paint more white on to the snow to add texture.

24 Use Payne's gray to paint the sheep's faces.

25 Use white to paint tiny details of snow in the distant fields and foliage.

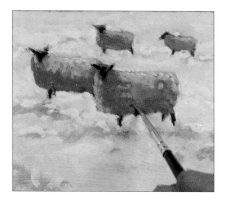

26 Mix ultramarine and yellow ochre and shade the undersides of the sheep to refine their shape.

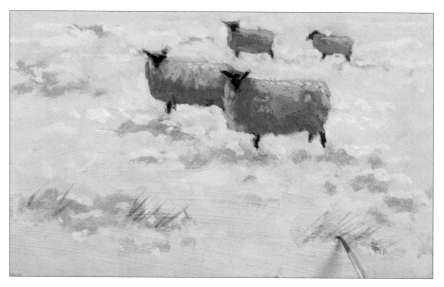

27 Use the same mix and brush to paint more defined grasses out of the grassy tufts already painted in the foreground.

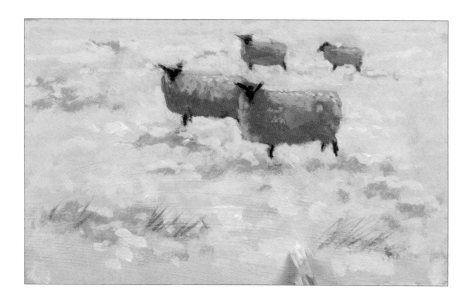

28 Paint dabs of white in the foreground snow to create texture.

The finished painting.

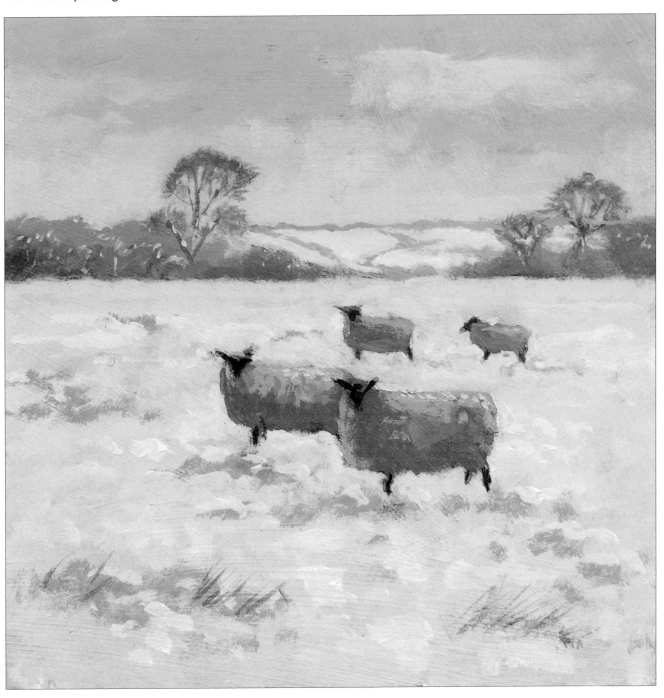

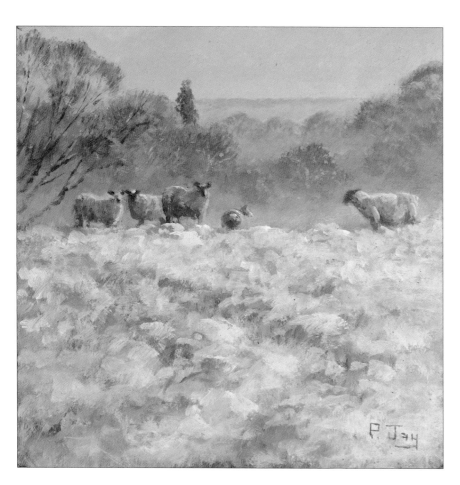

Waiting for Meal Time
16.7 x 16.7cm (6½ x 6½in)

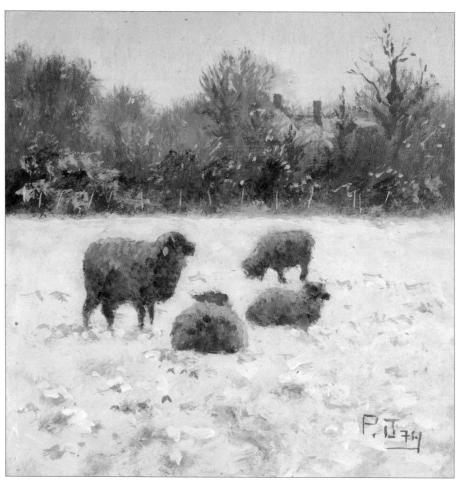

Farmer Bull's Sheep
12.7 x 12.7cm (5 x 5in)

February Frost
16.7 x 16.7cm (6½ x 6½in)

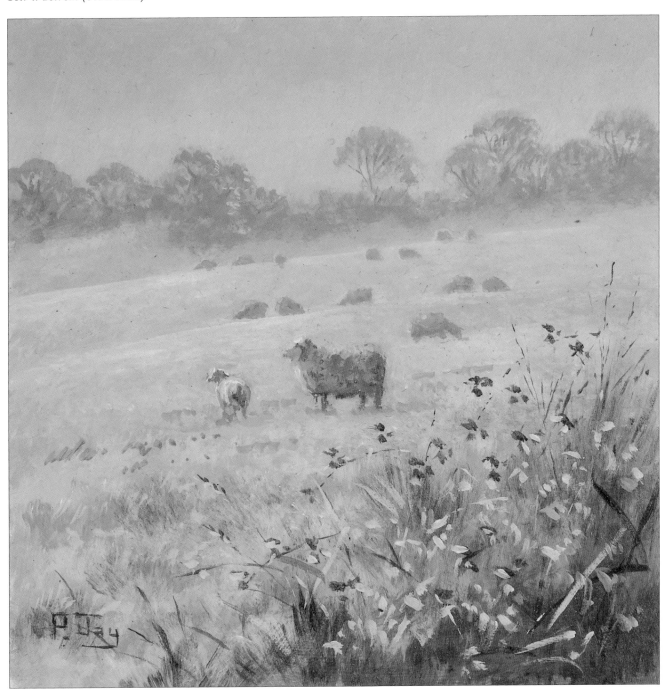

Track Through Hills

I always find the mystery of a disappearing track an irresistible subject for a painting. Combine this with distant blue hills and a wealth of wild flowers and I could be there for the day.

The 'Z' shaped composition is stabilized by the horizontal of the field in the middle distance and the large bush on the left. Again, perspective is created by the blue distance and the downward curve of the track is accentuated by the fence on its left.

You will need

Primed board 20.3 x 20.3cm (8 x 8in) and acrylic gesso

Charcoal

Colours: Venetian red, ultramarine blue, white, lemon yellow, cadmium yellow medium, cadmium yellow deep, yellow ochre, Payne's gray, cadmium red

Brushes: no. 1 round, no. 6 flat, no. 4 round

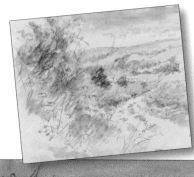

The sketch.

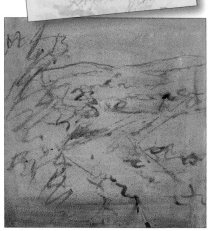

1 Coat the board with acrylic gesso, then paint an undercoat of Venetian red. Refer to the sketch and draw the scene in charcoal, then go over the lines with the no. 1 brush and ultramarine.

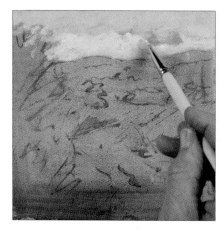

2 Mix ultramarine, white and lemon yellow and use a no. 6 flat brush to paint the top of the sky. Add more white to paint lower down.

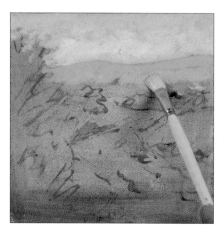

3 Paint the hills in the distance with a mix of ultramarine, cadmium yellow medium and white.

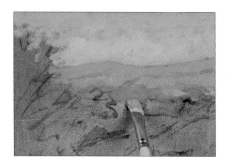

4 Use a darker mix with less white to paint some trees and hedges in the background.

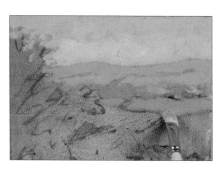

5 Mix ultramarine, cadmium yellow deep and white and block in the fields slightly further forwards.

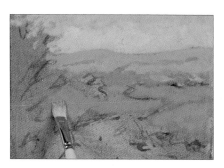

6 Add yellow ochre to the green mix and paint the fields and grasses nearer to the foreground.

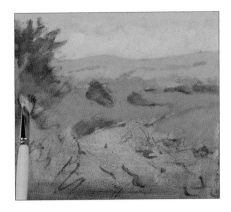

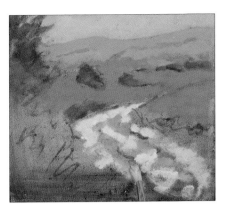

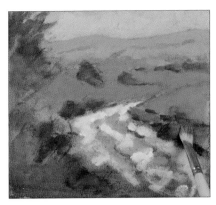

7 Block in the darker shrubs with a mix of ultramarine and yellow ochre.

8 Change to a no. 4 round brush and block in the path with pure white. Add ultramarine and cadmium yellow deep to pick out the grasses along the middle.

9 Mix ultramarine and cadmium yellow deep and use the no. 6 flat brush to block in the shaded grasses on either side of the path. Add more yellow for the sunlit parts.

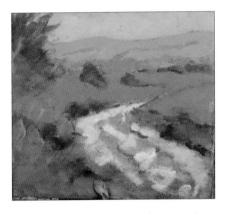

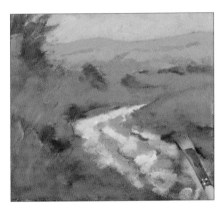

10 Mix yellow ochre with a touch of white and a touch of ultramarine and start painting in the grasses.

11 Mix ultramarine and cadmium yellow deep and add a little shading to the grasses and bushes. Fill in some of the areas of red undercoat that still show.

12 Change to the no. 4 round brush and use the sky mix of white, ultramarine and lemon yellow to work into the sky area, adding depth of colour. Add more white and a touch of yellow ochre for warmth to paint the sky near the horizon line.

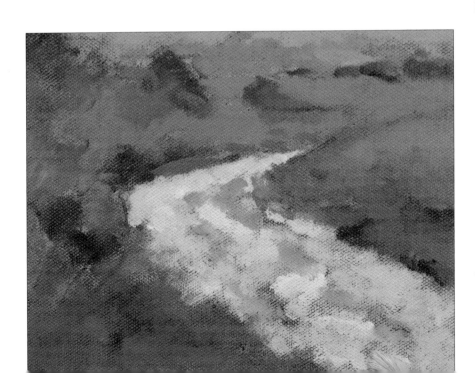

13 Touch the same colour in to the path.

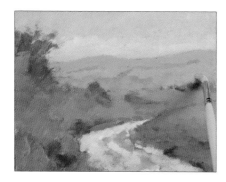

14 Add more ultramarine and cadmium yellow deep and go over the background trees.

15 Make a green mix of cadmium yellow deep with white and a little ultramarine and paint the fields in the distance with horizontal strokes.

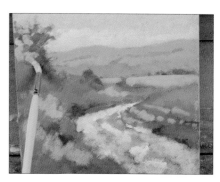

16 Use the same colour to work on the light areas of the grasses and on the big bush on the left.

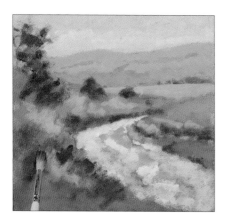

17 Mix ultramarine and cadmium yellow deep to make a dark green to shade the bush and grasses.

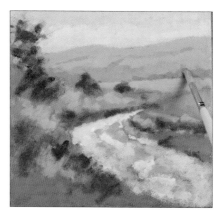

18 Add white to the mix and put in the line of trees and bushes in the middle distance.

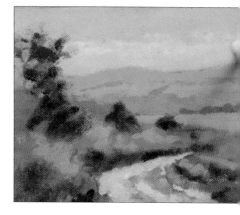

19 Still using the no. 4 round brush, add interest to the clouds with a pale mix of white with a touch of ultramarine and lemon yellow.

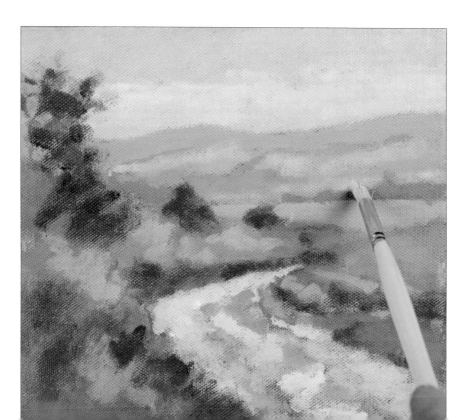

20 Add more ultramarine to the mix and pick out the fields in the background.

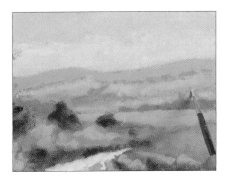

21 Take the fine no. 1 brush and use a diluted mix of ultramarine, yellow ochre and white to give further definition to the middle distant trees.

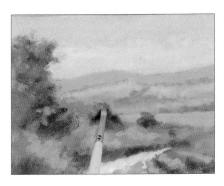

22 Change to the no. 2 round brush and mix ultramarine, white and cadmium yellow deep to lighten the sunny side of the bushes.

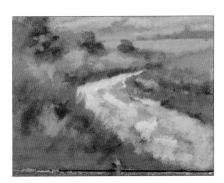

23 Mix white, ultramarine and lemon yellow to paint grasses growing alongside the path.

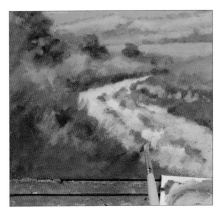

24 Use the same colour to pick up the grasses growing along the path itself.

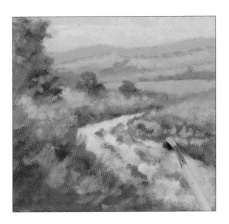

25 Paint in lighter areas of grass with a mix of yellow ochre and white.

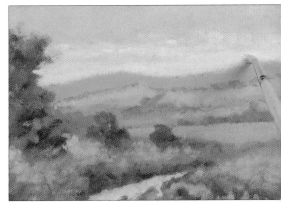

26 Mix white with a touch of lemon yellow to touch in the lower part of the sky for greater contrast with the distant hills.

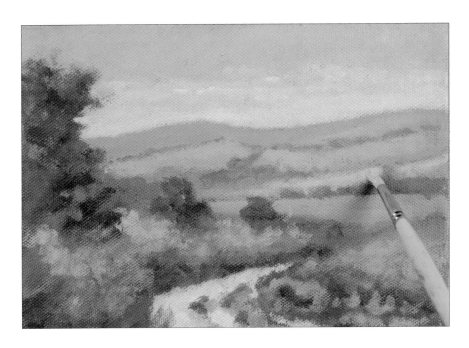

27 Add a little ultramarine to the mix to lighten the distant fields.

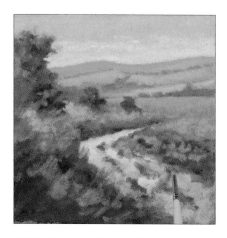

28 Still using the no. 2 round brush, touch in areas of the grass and shadows along the edge of the path with ultramarine, cadmium yellow deep and white. This bluer colour helps to unify the painting.

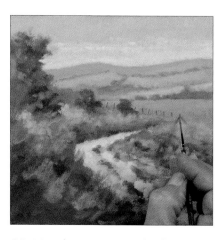

29 Mix ultramarine and yellow ochre and dilute it with water so that you can achieve a fine line, then use the no. 1 brush to paint the fence.

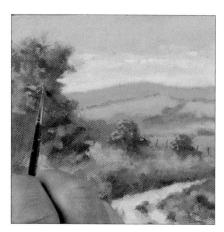

30 Mix cadmium yellow deep, white and ultramarine to make a pale green and paint highlights on the bushes.

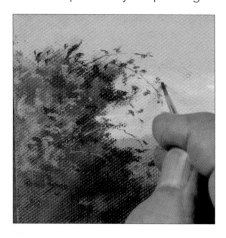

31 Use a mix of Payne's gray, cadmium yellow deep and ultramarine to paint the foliage of dog roses growing from the main bush.

32 Add quite a bit of white to this mix and paint the dog roses and grasses that go over the darker parts of the bush.

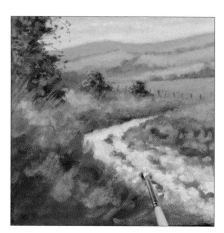

33 Work on the chalk path using the no. 2 round brush and white.

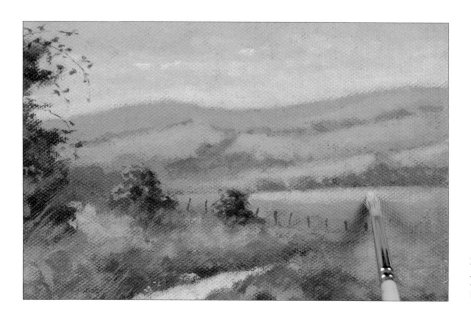

34 Mix white with a touch of lemon yellow to paint highlights on the middle distant field.

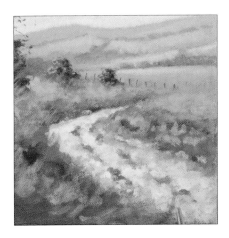

35 Mix white with a touch of ultramarine and yellow ochre and paint shading on the chalk path.

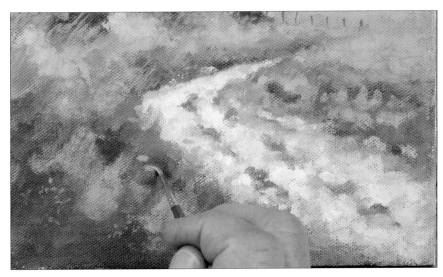

36 Paint yellow hawkweed flowers with a mix of yellow ochre and cadmium yellow deep.

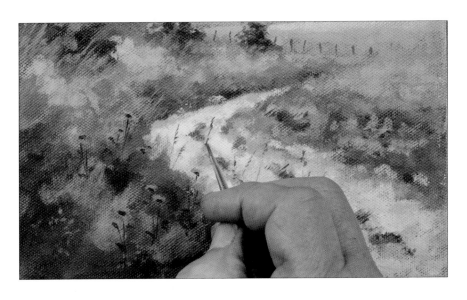

37 Add a little ultramarine to the mix and paint in the body of the plant and the stalks, as well as some grasses.

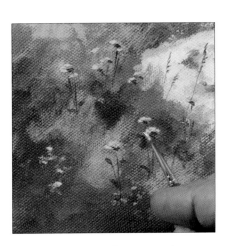

38 Highlight the flowers with a mix of cadmium yellow deep and white.

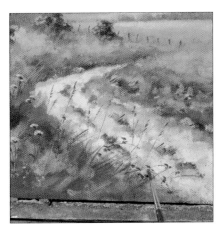

39 Mix ultramarine and yellow ochre and paint brambles to break up the line at the edge of the path.

40 Paint the dog rose flowers using a mix of white and a little cadmium red.

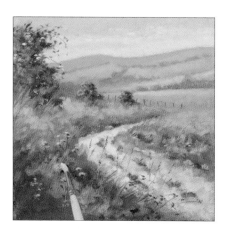

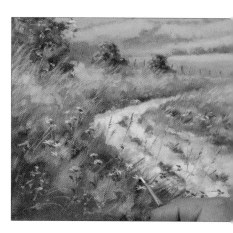

41 Use the no. 2 round and a mix of white, yellow ochre and cadmium yellow deep to paint paler areas of grass.

42 Change to the no. 1 brush and a dilute version of the same mix and paint pale grasses on both sides of the path.

43 Paint in ox-eye daisies with the same brush and white.

44 Paint the eyes in the daisies with cadmium yellow deep mixed with yellow ochre.

45 Paint shadows under the eyes of the daisies with a mix of ultramarine and yellow ochre. Finally use a mix of white and cadmium yellow deep to paint the stalks of the ox-eye daisies and various grasses where they pass over shaded areas.

The finished painting.

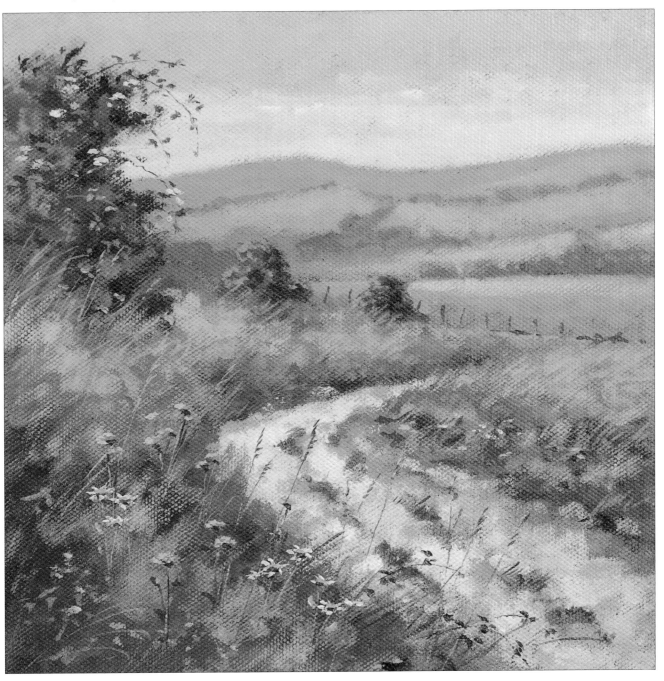

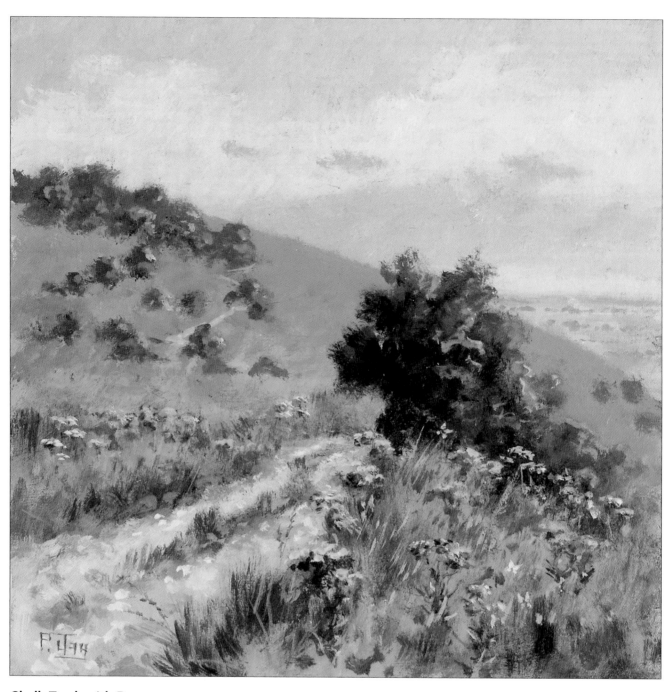

Chalk Track with Ragwort
20.3 x 20.3cm (8 x 8in)

Wild Flower Landscape
20.3 x 20.3cm (8 x 8in)

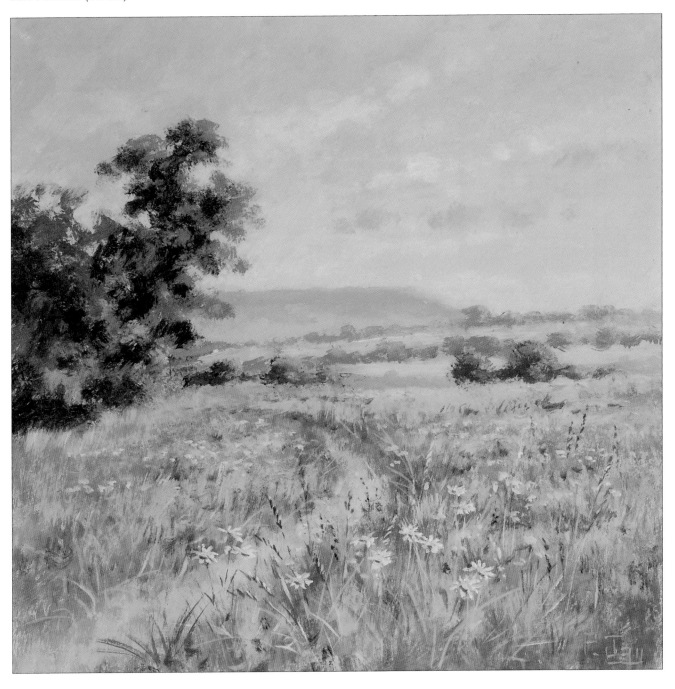

Poppies in a Daisy Field

What a treat to wander and paint in these wild flower meadows. This one in particular has far-reaching views where the principle of aerial perspective comes into its own. The far distant hills are some miles away and the darker blue is nearby forestry where wild boar roam. Slightly nearer are the trees bordering the top edge of the cornfield and then the greeny blue of the trees and hedges round the meadow itself. The foreground poppies catch the eye which is then led round the field path to the strong diagonals of the hedges.

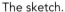

The sketch.

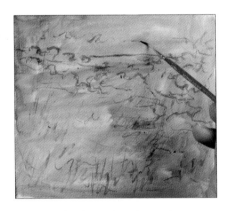

1 Coat the board with acrylic gesso, then paint an undercoat of Venetian red. Refer to the sketch and draw the scene in charcoal, then go over the lines with the no. 1 brush and ultramarine.

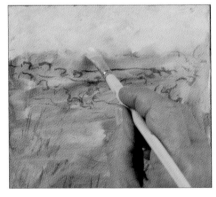

2 Paint the sky with a no. 6 flat brush and a mix of white, ultramarine and a little lemon yellow. Add more white for lower down. Work roughly, fading down towards the skyline.

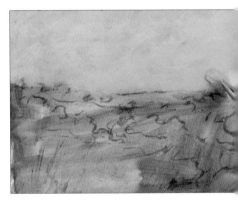

3 Add a little yellow ochre to the sky mix to suggest an evening sky.

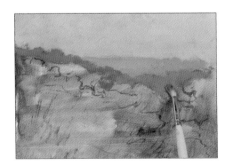

4 Mix white, ultramarine and cadmium yellow deep and paint the hills in the background. Then, with less white in the mix, paint the distant trees.

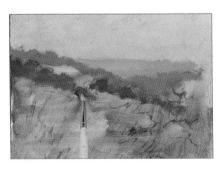

5 Add ultramarine and yellow ochre to the mix and paint more trees coming forwards.

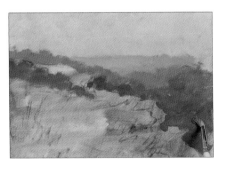

6 Make a darker mix of yellow ochre, ultramarine and cadmium yellow deep and paint a slightly stronger green hedge coming further forwards.

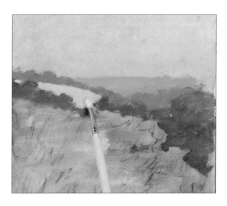

7 Clean the brush, then pick up a mix of white and yellow ochre and paint the cornfield in the background.

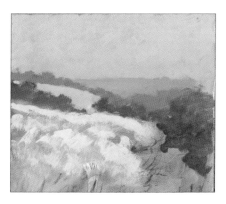

8 Create the shape of the wild flower meadow by painting it first with white.

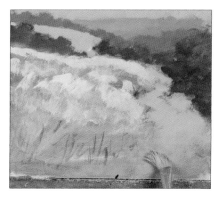

9 Mix cadmium yellow deep with a little ultramarine to paint the path round the edge of the meadow. Add a little more ultramarine for shadow.

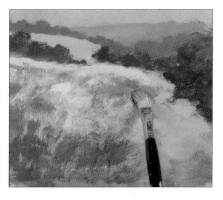

10 Use the same colour to paint patches of greenery in the meadow.

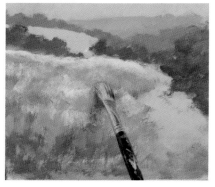

11 Add yellow ochre and white to the mix for a second green in the meadow.

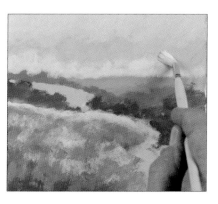

12 Change to the no. 4 round brush and mix white, ultramarine and lemon yellow. Work into the sky again from the top. Add a little yellow ochre and lemon yellow and paint near the horizon, working up towards the blue.

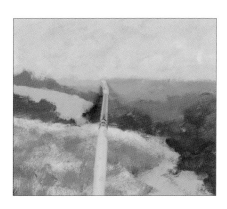

13 Take the no. 2 round brush and paint the distant hills with a mix of ultramarine, white and a little yellow ochre.

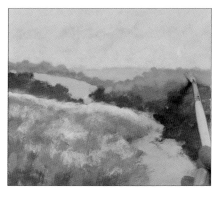

14 Add more ultramarine and yellow ochre to the mix to make it darker and work into the distant trees.

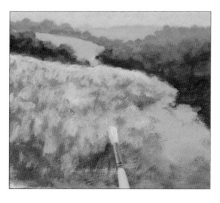

15 Add cadmium yellow medium to the mix and paint light on to the trees in the nearer background. Then change to the no. 4 round brush and work into the meadow with white, a touch of lemon yellow and a touch of ultramarine.

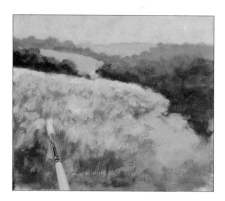

16 Add a little yellow ochre to the mix to fill gaps in the meadow.

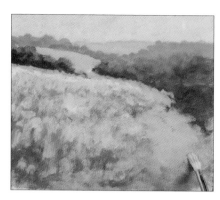

17 Add ultramarine and cadmium yellow deep to the mix and paint round the edges of the meadow for a shadow effect.

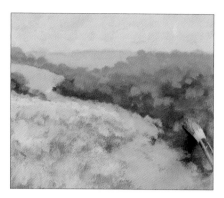

18 Mix ultramarine and cadmium yellow medium and add touches of this green on to the trees at the edge of the meadow.

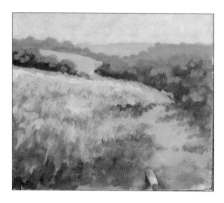

19 Strengthen the shadowed area of the meadow in the foreground with a mix of ultramarine, yellow ochre and cadmium yellow deep.

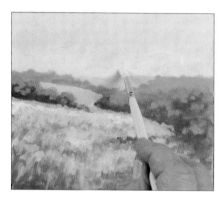

20 Mix white, ultramarine, yellow ochre and lemon yellow and paint the lower part of the sky again, working up into the blue.

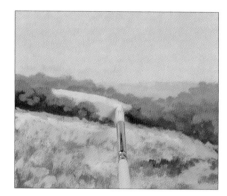

21 Paint the distant cornfield once again with a mix of white and yellow ochre.

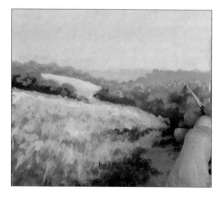

22 Change to the no. 1 brush and add a little shading to the trees in the background using a mix of ultramarine, cadmium yellow deep and white.

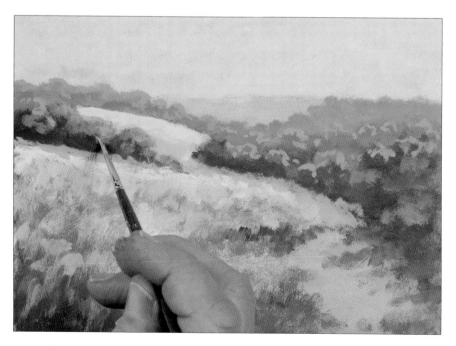

23 Lighten the mix with a little more cadmium yellow deep as the trees come slightly further forwards.

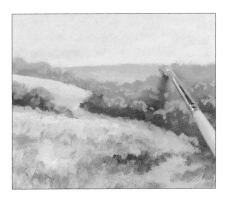 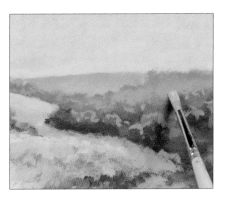 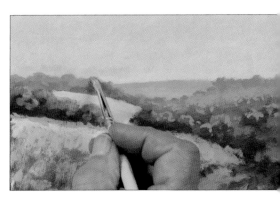

24 Use the no. 2 round brush to paint over the distant hills with ultramarine, cadmium yellow medium and white.

25 Fade the misty, distant trees with the same mix, to help create aerial perspective.

26 Add ultramarine and yellow ochre to the mix to give definition to the trees on the horizon.

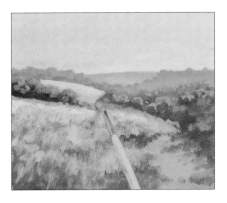 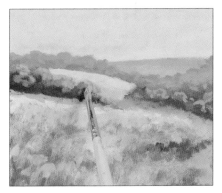 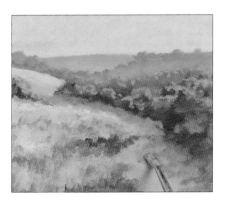

27 Add cadmium yellow deep to the same mix and tone down the shadows of the trees in the middle distance.

28 Add lemon yellow and white to the mix to paint highlights on the trees.

29 Mix ultramarine and cadmium yellow deep and work into the shadows of the hedge cast on the path.

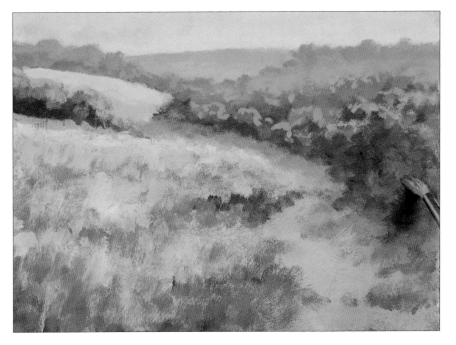 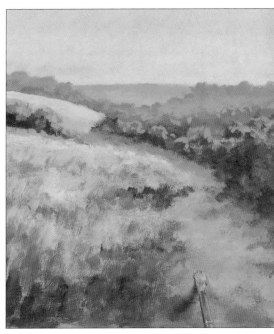

30 Paint the nearer part of the hedge with a darker mix of the same colours.

31 Mix white, cadmium yellow deep and a little ultramarine and work on the path in the foreground.

32 Add ultramarine to the mix to shade the path.

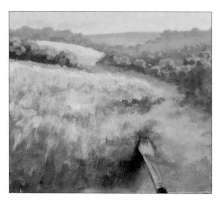

33 Change to the no. 6 flat brush and work into the foreground of the meadow with a green mixed from ultramarine and cadmium yellow medium.

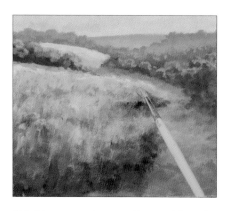

34 Now use the no. 2 round brush and a mix of white, ultramarine and yellow ochre and work in to the meadow.

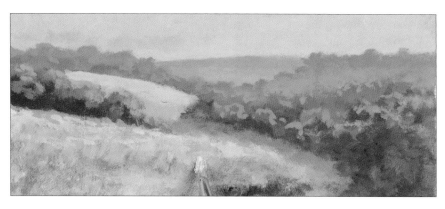

35 Use the same brush and white paint to pick out the mayweed in the far part of the meadow.

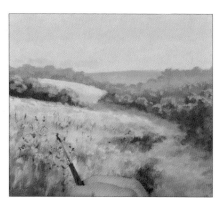

36 Change to the no. 1 brush and make a diluted mix of ultramarine and yellow ochre. Start picking out the stalks of tall thistles, distant docks and other wild flowers.

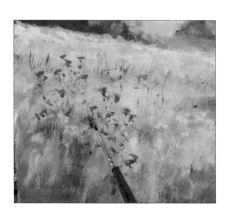

37 Mix alizarin crimson with a touch of ultramarine and a little white and paint the thistle heads.

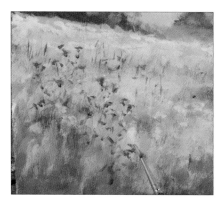

38 Add more white to the mix to highlight the sunny sides of the thistles.

39 Mix white with ultramarine and lemon yellow to make a very pale green and use this to highlight the stalks and prickles of the thistles.

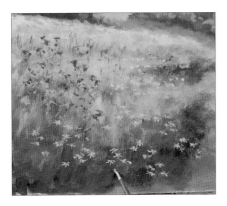

40 Next use the same brush and white to paint the white mayweed flowers in the foreground.

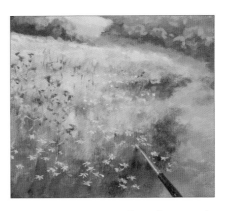

41 Mix cadmium yellow deep and yellow ochre and paint the centres in the flowers.

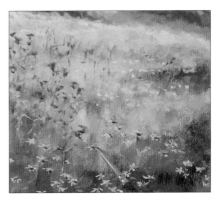

42 Add ultramarine to the mix and paint shadows under the centres.

43 Use the same mix to paint more leaves, stalks and grasses.

44 Add white to the mix and continue stalks that pass over darker areas of background.

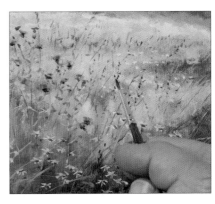

45 Use raw umber to paint the dock seed heads.

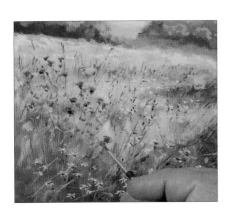

46 Brighten the thistle heads with a mix of alizarin crimson and ultramarine.

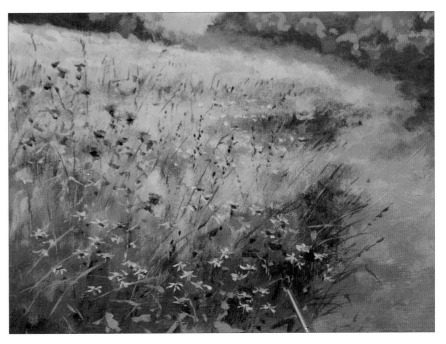

47 Paint the poppies with cadmium red.

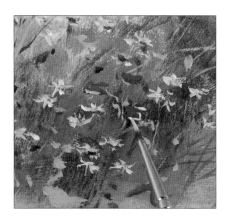

48 Add white highlights to the poppy petals.

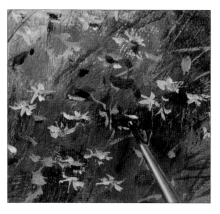

49 Give the poppies centres with Payne's gray.

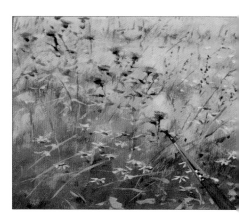

50 Mix ultramarine and cadmium yellow deep to strengthen the thistle sepals and stalks.

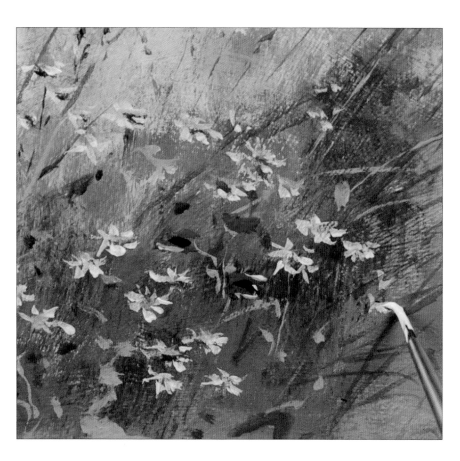

51 Use white to highlight the sunny side of the mayweed petals, and parts of the foliage.

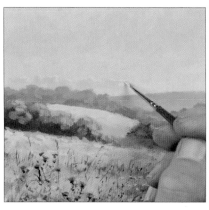

52 Still using the no. 1 brush, add a little yellow ochre to white and paint light on to the background clouds.

53 Mix ultramarine and lemon yellow to add life to the far distant trees.

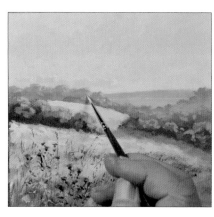

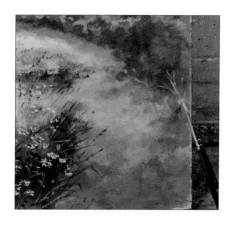

54 Mix white with yellow ochre and paint in a few grasses on the far right, at the edge of the path.

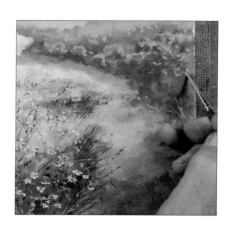

55 Mix cadmium yellow deep, ultramarine and white and paint brambles on the nearest part of the hedge to break up the darkness.

The finished painting.

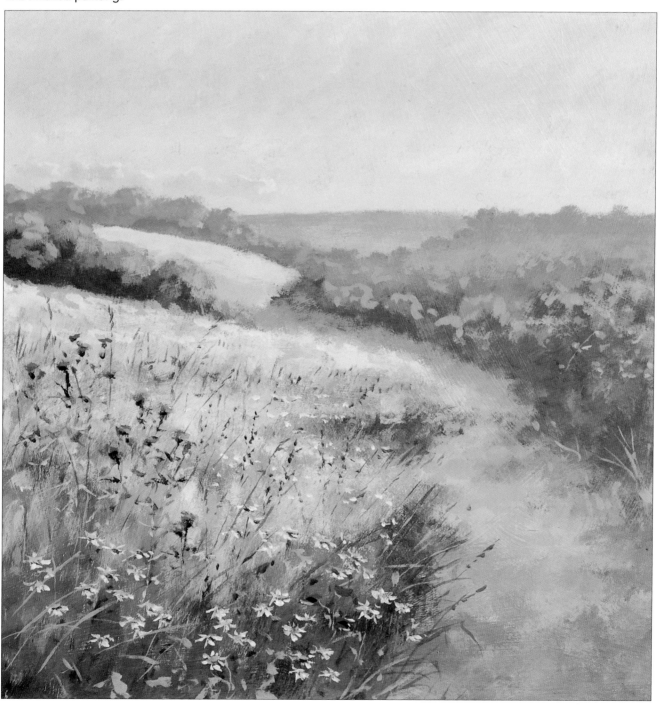

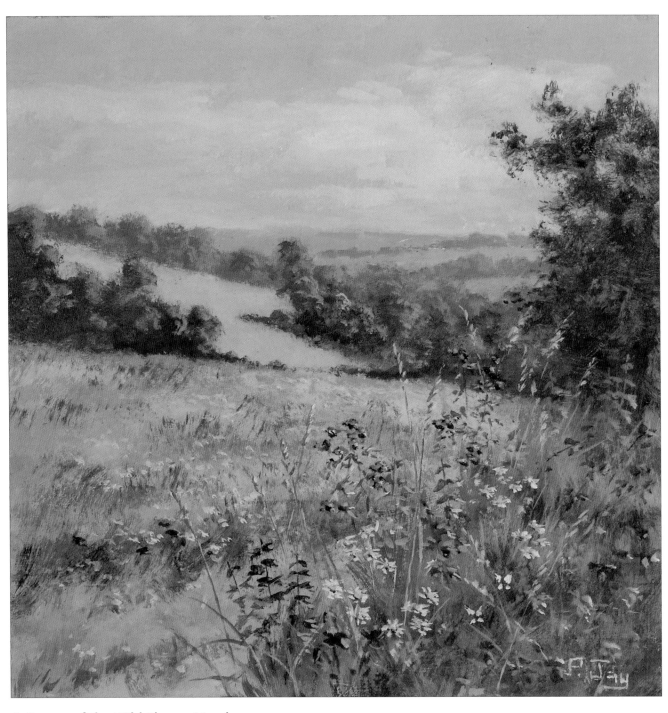

A Corner of the Wild Flower Meadow
20.3 x 20.3cm (8 x 8in)

Last Summer Swallows
20.3 x 20.3cm (8 x 8in)

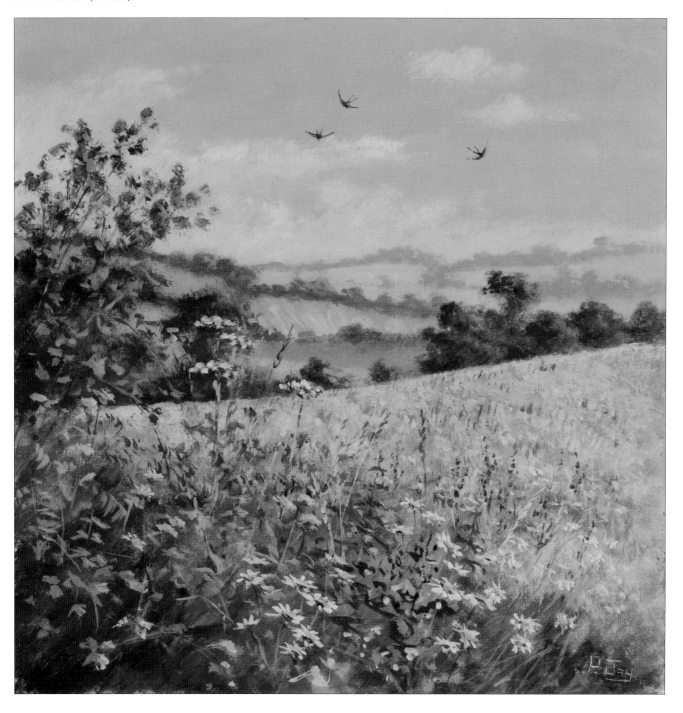

Index

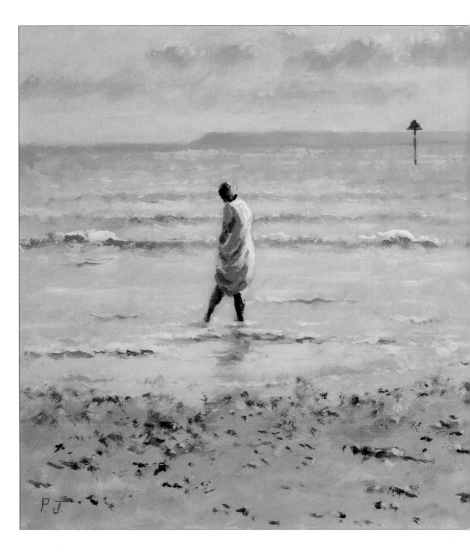

Testing the Water
20.3 x 20.3cm (8 x 8in)